IMAGES
of America

LITTLE ITALY

MARTIN GAULDIN

SUITE 239 RAILWAY EXCHANGE

CHICAGO, ILL.

TELEPHONE WABASH 361

OPPORTUNITIES ALONG *the* FOURCHE RIVER VALLEY & INDIAN TERRITORY RAILWA

The promise of quality farmland drew interested buyers looking for agricultural opportunities at the turn of the 20th century to Arkansas. Land agents promoted the possibility of "colonization" or the settling of an area by a particular ethnic group. Agents like Martin Gauldin advertised land in the "Highlands of Perry and Pulaski Counties" for as little as a few dollars per acre. Upon investigation of the land in the summer of 1915, Italians were astonished to find that the foothills of the Ouachita Mountains greatly resembled the hills of their Italian homeland. (Courtesy of the John Chiaro family.)

ON THE COVER: Angelo Ghidotti and his nephew Louis Segalla are shown spraying grape vines with fungicide in this photograph taken by a reporter for the Work Projects Administration (WPA) in May 1940. Ghidotti's family owned acres of vineyards and a bonded winery, which produced thousands of gallons of wine each year. Like most of Little Italy's residents, the Ghidottis depended on a bountiful grape harvest for their livelihood, and spraying the vines was only one step to ensure success. (Courtesy of the Arkansas History Commission.)

IMAGES
of America
LITTLE ITALY

Chris Dorer

ARCADIA
PUBLISHING

Published by Arcadia Publishing
Charleston, South Carolina

Printed in the United States of America

Library of Congress Control Number: 2015932176

For all general information, please contact Arcadia Publishing:
Telephone 843-853-2070
Fax 843-853-0044
E-mail sales@arcadiapublishing.com
For customer service and orders:
Toll-Free 1-888-313-2665

Visit us on the Internet at www.arcadiapublishing.com

*For Samantha and Allison, who never object to
my harebrained ideas—I love you.*

CONTENTS

ACKNOWLEDGMENTS

I did not realize it then, but this project really began in the summer of 2001 when I conducted interviews with the children of Little Italy's founding families for my first book. Though most of these individuals have since passed away, I quoted them to provide the context for many captions in this book. Because I grew up in their midst, these people were more than interview subjects to me, rather, they were like family—without their help so many years ago, this book would not be possible.

I am very grateful to all of the individuals who graciously offered their personal photographs to me and, in many instances, invited me into their homes. Those individuals include the following: John and Olga Dal Santo, Loretta Crosariol, Vince and Toni Chiaro, Marie Rankin, Eda Segalla, Angela Petursson, Anita Wagner, Barbara Penney, Lenora Newman, Angelina Dunlap, Martha Starks, Jim Mahan, Elaine Otto, Katherine Siegman, Joann Janssen, Gina Drawbaugh, Rico Belotti, Roger Rossi, Agatha Renalli-Penzo, Pauline Ghidotti, Louis Segalla, Margaret Forrester, DJ Cia, and Terry Vanzetti. Additionally, I wish to thank the *Arkansas Catholic* staff, especially Emily Roberts and Malea Hargett, who went above and beyond to provide me with resources from the newspaper's archives. Many thanks go to Kristy Eanes at the Diocese of Little Rock, who is also a Little Italy descendant and who set up appointments, contacted relatives, and offered encouragement throughout the project. I wish to thank Kaye Lundgren at the University of Arkansas at Little Rock (UALR) Center for Arkansas History and Culture, who was a tremendous resource in my research, as was the staff at the Arkansas History Commission. I wish to also thank Lydia Rollins and Julia Simpson, who provided constant support from Arcadia Publishing.

I especially want to thank my parents, Bob and Judy Dorer—without their support and encouragement this book would not be possible. To my daughter Allison, thank you for appreciating history as much as I do; it makes me happy. Finally, to my wife, Samantha, thank you for putting up with me during all of my projects and for loving me, despite me. You are my constant source of encouragement and support.

INTRODUCTION

Present-day Italy did not exist at the dawn of the 19th century. A conglomeration of a dozen nations constituted the Italian peninsula; some of these states were kingdoms, others republics, a handful were city-states, and there was even a papal theocracy. Swaths of land ruled by foreign powers like France and Austria intermingled with these small, regional governments. This added confusion to national boundaries, which had changed dozens of times since the dawn of the Renaissance four centuries earlier. By 1800, Napoleon Bonaparte claimed the familiar boot-like peninsula for France, but even under French control, Italian unity was not long-lived. In a little less than a decade, Bonaparte was defeated and his empire subsequently dismantled. European monarchs sought to make it impossible for future revolutionary leaders to rise up. Europe's chief monarchies adopted an agreement at the Congress of Vienna in 1815 to conserve the authority of the ruling class and reject future radical, revolutionary ideas like those that led to Bonaparte's power.

Post-Napoleonic Europe was burdened by strict conservatism that preserved powers of kings and nobles, while commoners possessed few rights. Property ownership, education, and voting rights were inconceivable for Europe's poor. By the mid-1800s, political upheaval and revolution spread through southern Europe. The fragmented and chaotic political structure of the area perpetuated injustice for the lower class, yet an intensified desire for political and cultural unity inspired change. Influenced by Enlightenment ideals, educated individuals advocated for a reformed system in which basic liberties increased and new national identities replaced regional ones. This new thought, known as nationalism, espoused the belief that people who share a common language, history, culture, and religion must be united politically, no matter the cost. Nationalism proved to be a catalyst for distrust among Europe's nations, and by the second decade of the 20th century, the First World War ravaged the continent. The unification of Italy in the 1860s resulted from this call for nationalism, or Risorgimento as Italians called it. After leading separate peasant rebellions, patriots Giuseppe Mazzini and Giuseppe Garibaldi advocated for the creation of a democracy, but the push for Risorgimento only strengthened the monarchy and created little change for the Kingdom of Italy's lowest classes.

The early families of Little Italy, Arkansas, were among the political and cultural refugees of post-unification Italy. Born as subjects of Italy's King Victor Emmanuel II in the decades following Risorgimento, these individuals grew in awareness of the unfulfilled promise of the Italian revolutionary movement. As young adults, they abandoned the tumultuous environment of their homeland in search of freedoms they believed were only attainable in America. Late-19th-to-early-20th-century European immigration into the United States differed greatly from the immigration that occurred in earlier centuries. Europeans from regional kingdoms on the Italian peninsula, the Germanic states, and Slavic regions replaced the British, Scottish, and Irish immigration of colonial times and early nationhood. Like many of their countrymen, the founders of Arkansas's Little Italy arrived in the United States and settled in Chicago.

The bustling industrial center in the Midwest boasted an Italian immigrant population of about 40,000 around 1910. Most immigrant men arrived in America alone; they found work, settled into dwellings, and sent for their families once they raised the funds necessary to do so. Despite the new setting, the cycle of oppression they abandoned across the Atlantic reemerged in America. Poor living and working conditions threatened the well-being of the men and their families. Meager earnings from factory jobs provided only enough for essentials. Without the availability of land in cramped neighborhoods, there was no possibility to supplement the food they purchased with homegrown vegetables; they yearned for an opportunity to leave Chicago.

By the onset of World War I, a number of men, including the heads of the first families to arrive in Little Italy—Joseph Belotti, John Segalla, Lorenzo Grenato, Antonio Busato, and John Perin, resolved to better their families' lives. Disappointed by a foreign environment not unlike the volatile and abusive conditions of their homeland, and intrigued by claims of premium farming ventures, the men traveled by train to investigate the possibility of establishing a colony of Italian settlers in the foothills of the Ouachita Mountains. The region's rolling hills, climate, and long growing season reminded the men of northern Italy—the place they scornfully abandoned a decade earlier. They returned with their families in December 1915, and by spring, they began cultivating the land. Using their knowledge of grapes, they planted hundreds of acres of vineyards and established four wineries. Within 10 years, 15 families populated the countryside of rural Pulaski and Perry Counties. They raised grapes, established a Catholic church, and slowly adjusted to the pioneer lifestyle.

Life within Little Italy changed when Prohibition began in 1919; the Eighteenth Amendment threatened the colony's chief product, alcohol. Though it likely appeared detrimental to the settlement's prosperity at the time, this law advanced Little Italy's prominence in Arkansas history. Prior to and during Prohibition, the wine-making Italians of Little Italy raised hundreds of acres of grapes, boasted four wineries, and produced thousands of gallons of alcohol yearly.

It was not uncommon for reports of death from tainted alcohol to make the news throughout the 1920s and 1930s. Companies marketed medicinal elixirs with questionable ingredients to unsuspecting buyers, and tragedy often resulted in the name of profit. During Prohibition, Little Italy's winemakers provided the inhabitants of the state's most-populated region with a clean, reliable source of alcohol. The settlement became a popular destination for many of the state's most-powerful politicians who secretly imbibed the wine or cognac, for which the locals gained statewide notoriety. This sped up their assimilation process and allowed the Italians to gain widespread acceptance among their American counterparts. They became an oddity for the people of Central Arkansas and consequently established a culture, industry, and faith in the previously remote region.

Little Italy's influence extended far beyond alcohol. Within a generation, the residents owned successful businesses in Little Rock, while others used their craftsmanship skills to impact the architectural legacy of the region by constructing stone public works or laying terrazzo marble floors in government buildings. The wine industry dwindled in the 1940s and 1950s, sending the younger generation to seek jobs elsewhere. By the 1970s, all of the original adult settlers were deceased, signaling the return of their children to reclaim familial homes in retirement.

Two thousand fifteen marks the centennial of Little Italy's establishment. Within the last year, the community gained regional attention as locals undertook an effort to incorporate into a municipality, and An Enchanting Evening winery became the first commercial winery to operate there since the 1950s. St. Francis Church, founded in the early 1920s, remains the cohesive tie that binds the community. The bazaar hosted by the church each fall, which began as the grape-harvesting festival nearly 90 years ago, draws visitors from across the region each October. A century later, the charm and nostalgic atmosphere that exudes from the community are reminders of the immigrants' struggles for a better lives.

One

THE EARLY IMMIGRANT FAMILIES

Five families constituted the initial wave of settlers into Little Italy in 1915. The families traveled to Arkansas from Chicago via the Chicago, Rock Island and Pacific Railroad, which offered service to a small town located along the Arkansas River named Ledwidge. The immigrants loaded their belongings onto wagons and made their way to the land they purchased two miles away. They settled into a shell of a home, which they had ordered built, and while others houses were constructed, the families cohabitated, one in each corner of the home and one upstairs. By the following December, four more homes dotted the countryside, and more families soon followed. The farmers turned the rocky, mountainous soil into vineyards and used their knowledge of grapes to produce wine. Agricultural endeavors like commercial vineyards required a large labor force, and the already large Catholic families grew in size to meet this need. Rarely did a year pass in which no children were born. The 1920 census counted over 40 children, a handful of whom were born in the preceding five years. New families arrived each year, bringing names like Ghidotti, Chiaro, Zulpo, Vaccari, and Carraro. The Perins moved to North Little Rock and were replaced by the Balsams. The Granatos returned to Chicago and exchanged their house for the Crosariols' Chicago home.

The residents experienced tragedies not unlike other rural communities in this era. Unexpected deaths, fire, and economic hardship plagued the Italians, but the small community provided a family-like support network for those who lived there. Intermarriage among the younger generation further linked the families together. Subsequent waves of children grew up not only with their siblings, but surrounded by scores of aunts, uncles, and cousins of varying degree. The family served as the core unit through which the Little Italians passed on their culture and faith. These ideas allowed families to remain closely knit across the generations and to share a work ethic that ensured future success.

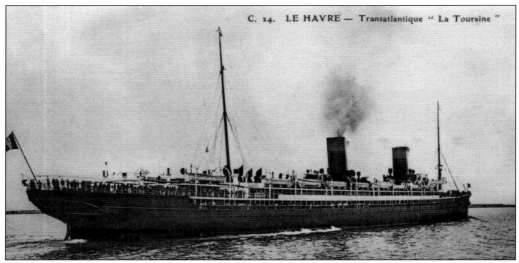

The SS *La Touraine*, which sailed from Le Havre, France, served as one of the largest passenger liners for Southern Europeans between 1890 and 1910. The Compagnie Générale Transatlantique operated the ship, which was outfitted to serve approximately 1,000 passengers in all classes. The ship was decommissioned in the early 1920s. Many of Little Italy's settlers traveled aboard this vessel from France to Ellis Island. (Courtesy of Little Italy Centennial Committee.)

The Domenico Zulpo family, including his son John, whose passport is shown here, sailed on the SS *La Touraine* to New York via Le Havre in the late 1890s. Upon arrival at Ellis Island, the Zulpos likely experienced overwhelming confusion as they navigated through an endless series of inspections, examinations, and bureaucratic regulations. (Courtesy of Lenora Newman.)

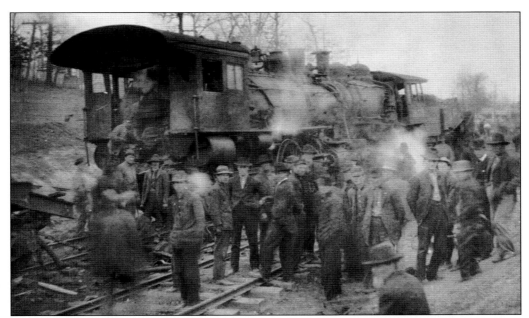

Located along the Arkansas River in rural Perry County, Ledwidge boasted a Chicago, Rock Island and Pacific Railroad depot, a general store, dozens of houses, and a small schoolhouse. Ledwidge was the nearest depot to the land purchased by the Italians, and they arrived there on December 23, 1915. The town suffered a severe flood in the 1950s, and most of the buildings were lost in the disaster. (Courtesy of Jim Mahan.)

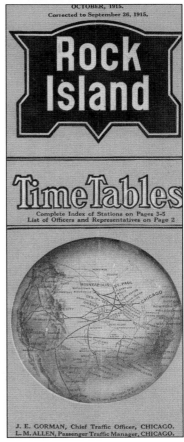

The Chicago, Rock Island and Pacific Railroad operated a vast network of lines between the Midwest and the Southern United States. One of the railroad's southernmost routes stretched between Memphis and Oklahoma City, with over 60 stops in Arkansas, including Ledwidge. The Italians likely used a timetable such as this one from October 1915 to plan their trip. (Courtesy of the Little Italy Centennial Committee.)

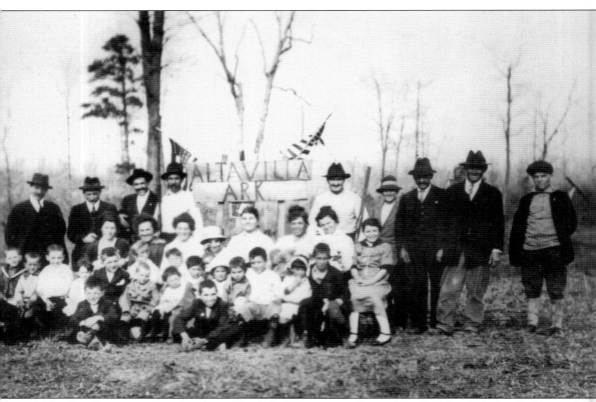

The first five immigrant families of Little Italy pose proudly in what they decided to call Alta Villa, or the High Place, in 1916. The party arrived via train at nearby Ledwidge and then trudged two miles uphill through the Arkansas wilderness. When they arrived at a shell of a home Joseph Belotti ordered constructed for them, Lorenzo Granato cried, "Oh my God, what have we done to our children?" Granato was the first to leave the settlement. The harvesting of virgin timber by lumber companies in the prior decade created the barren landscape seen behind the group. (Courtesy of Lenora Newman.)

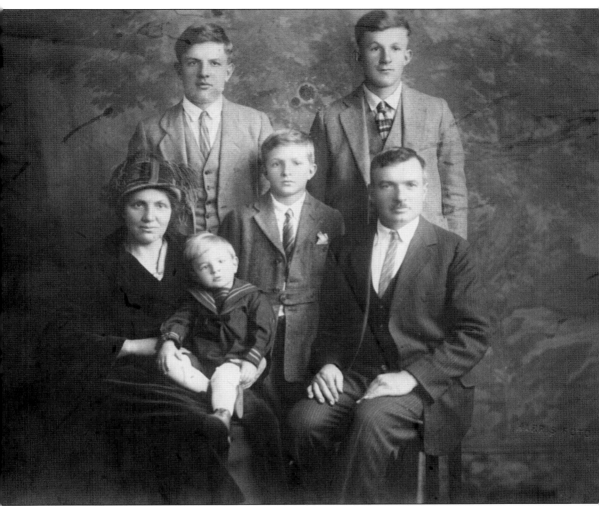

Born in Italy in the early 1880s, both Lucia and John Segalla came to Arkansas from Chicago in the first wave of settlers in 1915. Pictured with his family around 1921, Segalla was often viewed as the patriarch of Little Italy. The Segallas were one of the wealthiest families in the settlement and used their relative wealth to aid many of the other immigrants who struggled upon arrival. Pictured are, from left to right, (seated) Lucia, Benjamin, and John; (standing) Edo, Johnny, and Americo. (Courtesy of the Louis Belotti family.)

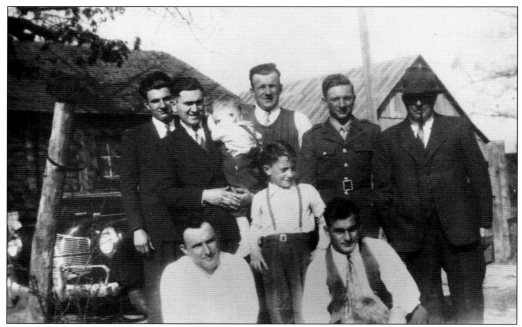

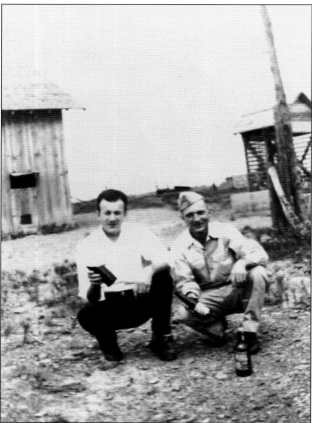

The Segallas established two businesses after their arrival in Arkansas, a winery in Little Italy and a horseradish factory at Eighth and Center Streets in Little Rock. Their son Americo, seen wearing a sweater vest, operated the horseradish business for his parents until it closed in the 1950s. Three generations of Segalla men are shown in this photograph: (standing, from left to right) Benjamin, Americo, Johnny, and John Segalla Sr., along with friends Angelo Ghidotti and John Chiaro. The boy standing in the front row is Louis Segalla. At left, brothers Americo (left) and Johnny Segalla pose with Segalla brand wine. (Both, courtesy of Eda Segalla.)

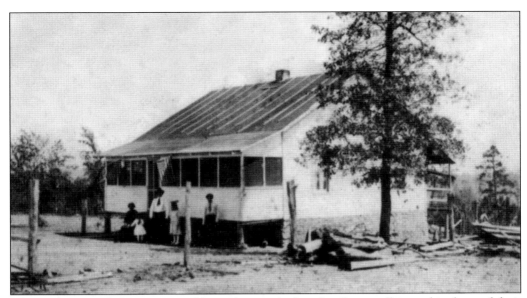

John and Genovefa Perin, pictured here along with their family, proudly posed in front of their house around 1917. The Perins left Little Italy in 1920 and settled in what is now North Little Rock, where a road is named for them. Their house and property were sold to Bertolo and Maria Balsam, who remained in the home until their deaths. (Courtesy of Elaine Otto.)

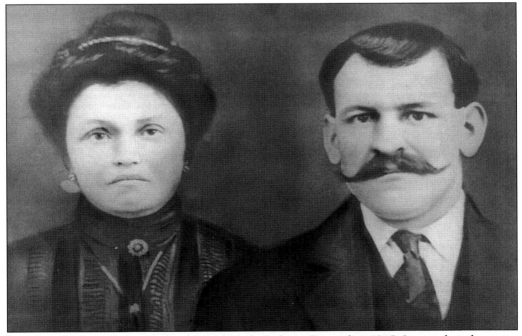

Joseph and Maria Belotti helped found Little Italy in December 1915. It was their home in which all five families lived until other dwellings could be built. Born in Bergamo, Italy, in 1879, Belotti was employed by the Pullman Rail Company in Chicago prior to moving to Arkansas. He feared his children would grow up to be gangsters if they did not leave the city and return to an agricultural lifestyle. (Courtesy of the Louis Belotti family.)

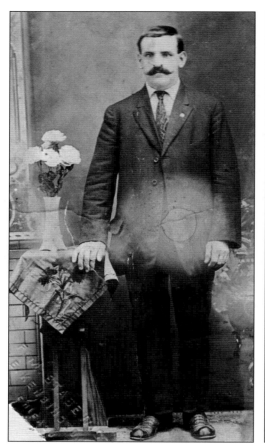

This photograph of Joseph Belotti survived the fire that caused his death and consumed his family's home. The effect of the heat can be seen in the lighter circular pattern over his torso. In preparation for a trip to Little Rock to sell potatoes at market, Belotti filled his automobile with gasoline early on the morning of June 20, 1929. The lantern Belotti was using ignited the gasoline fumes, and he was soon engulfed in flames. The fire quickly spread to his home, but the other family members were able to make it out of the home alive. The home was a total loss. Still on fire, the farmer ran through his vineyard until his son caught him and cut off his burning clothes. Belotti perished later that evening at St. Vincent's Hospital. (Both, courtesy of Jim Mahan.)

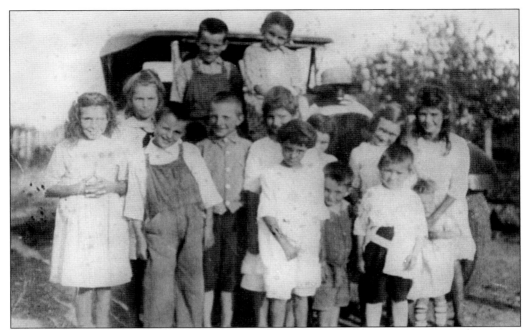

Dozens of young children made the trek with their parents from the Midwest to Arkansas in 1915. Katie Ghidotti Segalla recollected the following in 2001: "I was seven years old when I hit Ledwidge down here . . . Oooh, I saw that big mountain—I never saw a mountain before . . . we were so excited. We got excited about the cows and the animals, you know." Excitement soon turned to hard work for the community's children, and as the families settled into their new lives, more children were born in Arkansas. Pictured above are, from left to right, (first row) Marie Granato, Charles Belotti, Angelina Granato, Angelo Belotti, Raymond Vaccari, Yolanda Perin; (second row) Grace Granato, Johnny Segalla, Marie Perin, Vera Vaccari, Irma Vaccari, and Provina Perin; (third row) Louis Belotti and Antonia Belotti. (Both, courtesy of the Louis Belotti family.)

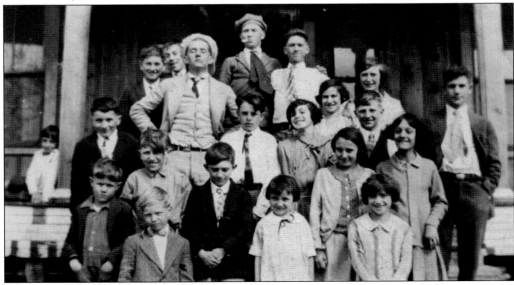

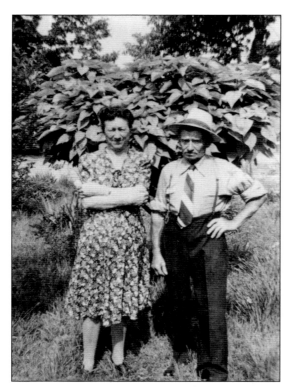

Ambrogio and Angela Vaccari moved to Arkansas in 1920 from Upper Peninsula Michigan, where Vaccari was employed in the region's iron mines. The couple co-owned a tavern and winery in Little Italy with their childhood friend Gelindo Solda, who served as *santolo*, or godfather, to each of the Vaccaris' five children. (Courtesy of Olga Dal Santo.)

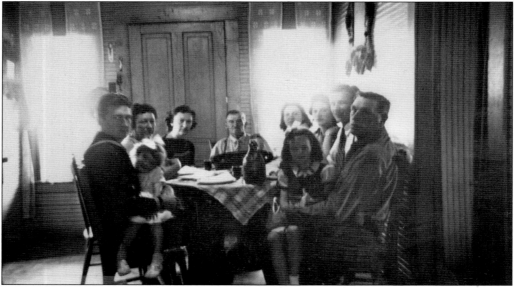

During Prohibition, the Vaccari family often hosted influential politicians at their home to eat, drink, and purchase wine or other liquor. Politicians such as Atty. Gen. Carl Bailey and numerous Perry and Pulaski County officeholders wrote letters to Angela Vaccari asking her to prepare a meal of chicken and spaghetti for them on an appointed day; this was an indication to the family that the politician was low on his supply of alcohol and needed to purchase more. (Courtesy of the Louis Belotti family.)

Geographical isolation, cultural familiarity, and childhood romances caused a large amount of intermarriage between families. For example, the marriage between John Chiaro and Antonietta Ghidotti (center) in December 1938 was a joyous occasion for two of the area's oldest families. Few people married outside of the local families, especially before 1940, but as transportation and communication eased, more Italians began to look outside of the community for their spouses. Pictured here are, from left to right, (first row) Ava Zulpo and Louis Segalla; (second row) Louisa Ghidotti, Johnny Chiaro, Antonietta Ghidotti, and Johnny Segalla. (Courtesy of the John Chiaro family.)

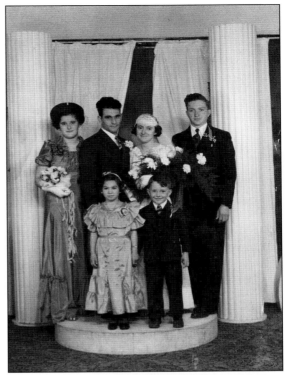

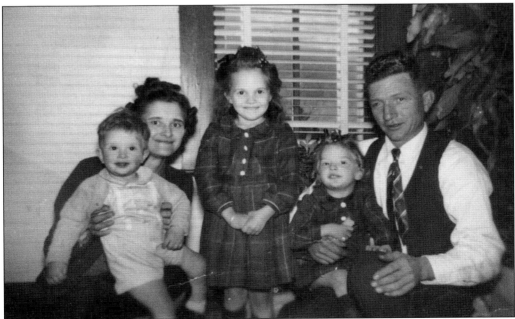

The Segalla and Ghidotti families had one of the deepest bonds in Little Italy because two marriages occurred between the families. The fruit of that connection is shown here, as Johnny Segalla and Louisa Ghidotti show off their young family, around 1948. Pictured, from left to right, are Johnny, Louisa, Marie, Eda, and Johnny. (Courtesy of Eda Segalla.)

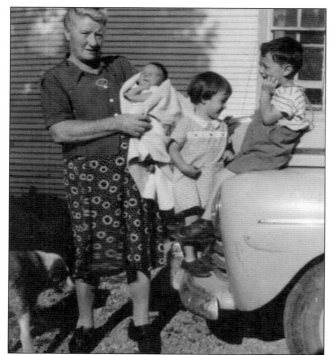

Maria Busato, or "Rosa" as she was called because of her auburn hair, became Little Italy's first widow. In June 1926, Busato's husband, Antonio, and 10-year-old son Fulvio were struck by lightning in the community's cheese house during a thunderstorm. The cheese house was located in the center of the community, and upon finding her loved ones dead inside, she screamed so loudly distant neighbors heard her. She later married Frank Zulpo, a local bachelor. She was plagued by tragedy throughout her life, and only one of Busato-Zulpo's five children survived into adulthood. She is seen with her grandchildren (left) and Zulpo (below). (Left, courtesy of Jim Mahan; below, courtesy of Agatha Renalli-Penzo.)

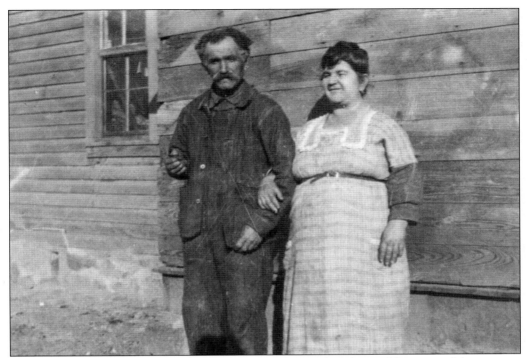

The only Southern Italians among those who resided in Little Italy were Vincent and Annunziata Chiaro, who hailed from Calabria, the mainland Italian state closest to Sicily. The Chiaros arrived in Arkansas in 1918 along with the Ghidotti family. Despite subtle cultural differences between them and their northern neighbors, they quickly fit in. (Courtesy of Lenora Newman.)

No. 1034 CHICAGO, Oct 16 1915

RECEIVED OF Charo Vincenzo

Twenty & no/100 — DOLLARS

payment on Ark Land

$ 20.00 Martin Gauldin

MARTIN GAULDIN.
ARKANSAS LANDS
239 RAILWAY EXCHANGE
CHICAGO, ILL.

This 1915 receipt for a $20 payment made by Vincent Chiaro to Martin Gauldin for his homestead in Arkansas represents a key milestone in the immigrant's quest for a better life. The debt was paid in full by the following year; the Chiaros moved shortly thereafter. Chiaro's farm cost him less than $500, or about $8 per acre with interest. (Courtesy of the John Chiaro family.)

Domenico and Antionia Zulpo immigrated to Arkansas in the 1890s and settled at Sunnyside Plantation in Chicot County. Sunnyside was the first and largest Italian colony in Arkansas, but it was the least hospitable. The system of peonage that bound the immigrants to their land was so oppressive that most of the settlers left the colony within five years. A large delegation, including the Zulpos, moved to Tontitown in the northwest corner of the state. (Courtesy of Lenora Newman.)

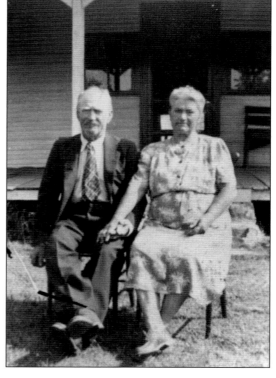

Pietro and Carlotta Carraro departed Italy and initially settled in Brazil, where they owned a coffee plantation before settling in Michigan in 1907. This South American detour made them unique among the families of Little Italy, but not among Italians in general. Many emigrants from Italy settled in South America in the late 19th and early 20th centuries because of the production of cash crops such as sugar and coffee. (Courtesy of Martha Starks.)

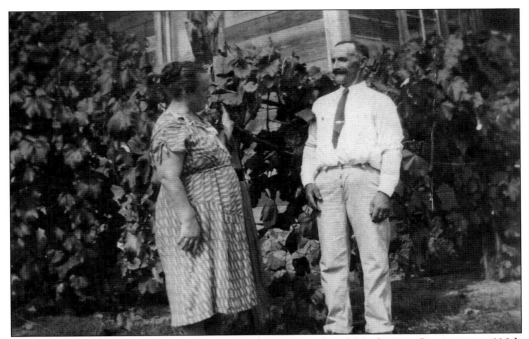

Sperandio Ghidotti (right) worked at the American Steel and Machinery Company on 116th Street in Chicago before moving to Arkansas with his family in 1918. Both Ghidotti and his wife, Antonia, were born near Brescia, Lombardy, in 1879 and 1881, respectively. The Ghidottis moved to Little Italy at the behest of her sister Maria Belotti. (Courtesy of the John Chiaro family.)

The Ghidottis had seven children, including a set of twins, one of whom died as a toddler before they arrived in Arkansas. In 1922, their eldest son, Louis (not pictured), died at age 15. He was the first immigrant to die in Little Italy, and did so before a cemetery was dedicated for the settlement. He was buried at Wye Cemetery three miles away, but his body was exhumed a few years later and reinterred at St. Francis Cemetery. This photograph was taken shortly after his death. Pictured are, from left to right, (first row) Sperandio, Antonietta, Antonia, and Louisa Ghidotti; (second row) Ventareno, Angelo, and Catherine Ghidotti; (in window) Charles Belotti. (Courtesy of Eda Segalla.)

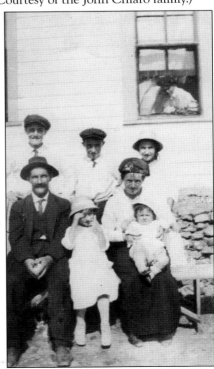

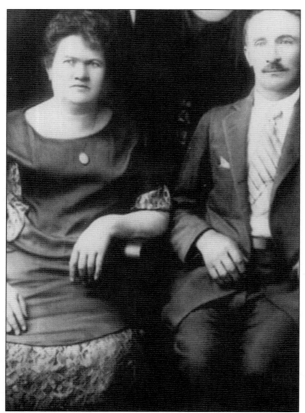

Giuseppe and Caroline Dal Santo were born in Vicenza, Veneto, Italy, in 1876. In 1902, they arrived in America with three small children—Wilbert, Angelo, and Ginnevive. Twins Edo and Clara were born once they settled in Chicago. By the outbreak of World War I, the family lived in Little Italy. Caroline served as local midwife and delivered many babies in the settlement. (Courtesy of Martha Starks.)

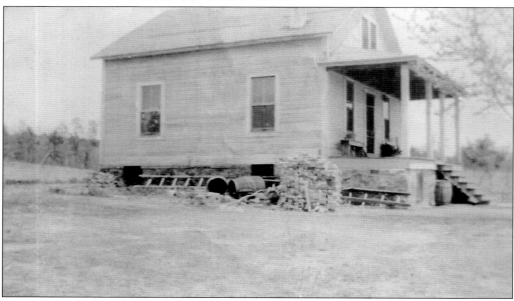

Like the other homes in the settlement, the Dal Santo home was equipped with a cellar. Inhabitants stored food and wine and hung meat to cure in these spaces. The subterranean rooms maintained a constant 65-degree temperature no matter the season. (Courtesy of Margaret Forrester.)

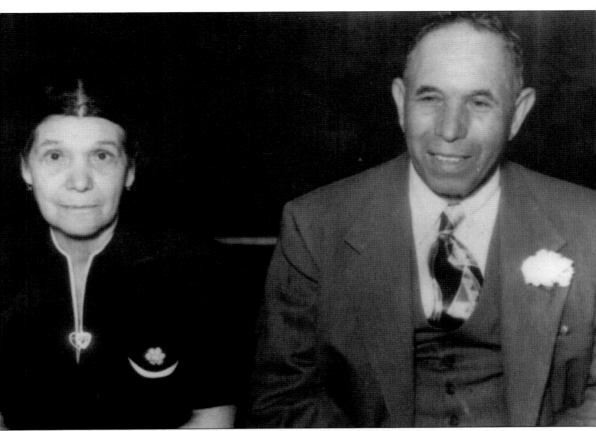

Lorenzo and Filomena Granato were in their early 30s when they arrived in Little Italy in 1915. When married for just 10 years, the couple brought four children with them to Arkansas, and another was born in Little Italy in 1917. The Granatos were one of two original couples who left Little Italy within the first five years and the only couple to return to Chicago. Upon their return, Granato took a job at Sherwin-Williams Paint Company, where he continued to work for many years. (Courtesy of Roger Rossi.)

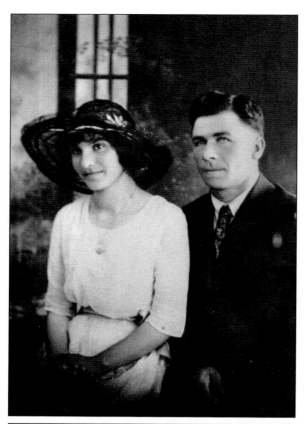

John Zulpo was an adult when his parents moved to Little Italy in 1920. He soon met Angelina Chiaro and was smitten with her beauty. After several unsuccessful attempts to gain her attention, Zulpo met with her father and asked for her hand in marriage. He was 27 years old, and she was 15 when they married in June 1921; they were the first couple to do so in Little Italy. (Courtesy of Lenora Newman.)

At the turn of the 20th century, Bertolo Balsam and his family settled in Iron Mountain, Michigan, where he worked in the iron mines of the nearby Tobin Location. Iron Mountain had a large Italian population and contained many modern amenities, which were provided by the mining companies. Balsam, his wife, Maria, and their family moved to Little Italy in 1920. (Courtesy of Joann Janssen.)

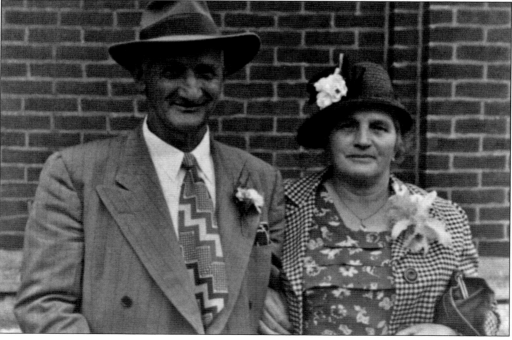

Like most couples in Little Italy, the Balsams had a large family; of seven children, only two were females. Each time Maria Balsam gave birth, her eldest daughter Giovanna begged her to "make it a girl!" She was disappointed four times until age 12, when her sister Tina was born. Her parents jokingly informed her that she had a new brother. She replied, "Take him back!" When she saw the infant, the older sister claimed the baby as her own. Here, the older Balsam girl dotes on her younger sister in a studio photograph taken in Little Rock. (Courtesy of Katherine Siegman.)

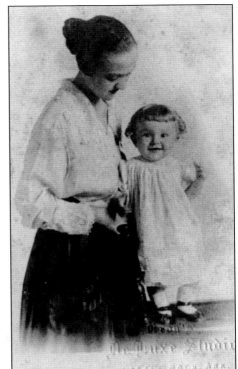

The Balsams, along with their children and grandchildren, gathered together in the early 1940s for this photograph. Bertolo Balsam operated winery No. 134 until his death in 1952, and his wife, Maria, donated the land on which the current St. Francis Church is built. (Courtesy of Joann Janssen.)

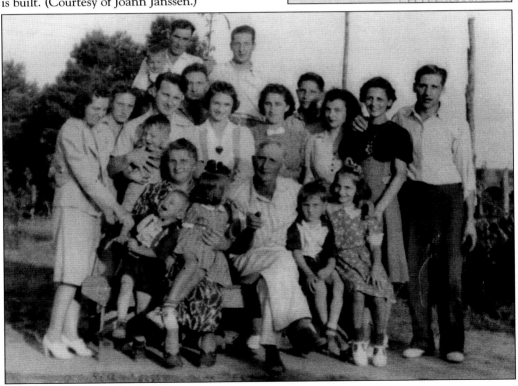

Following the traditions of their homeland, Italian couples practiced the traditional law of inheritance called primogeniture. In this system, the eldest male child inherits the family's wealth upon the death of his parents. Though Raymond Vaccari (left, wearing necktie) had two older sisters and two younger sisters, he inherited his parent's home and property. His four sisters received property from their godfather, Gelindo Solda. The Vacarri homestead is seen below in the 1930s. (Left, courtesy of Olga Dal Santo; below, courtesy of Loretta Crosariol.)

James and Verina Cia were the youngest couple to come to Little Italy. The Cias met and married in Massachusetts in 1911 and moved to Arkansas by the early 1920s as part of the second wave of immigration into the area. By the 1930s, the Cias owned a restaurant in downtown Little Rock at Markham and Spring Streets called James Cia's Eat Place. (Courtesy of the John Chiaro family.)

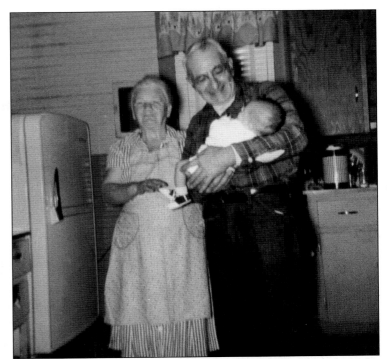

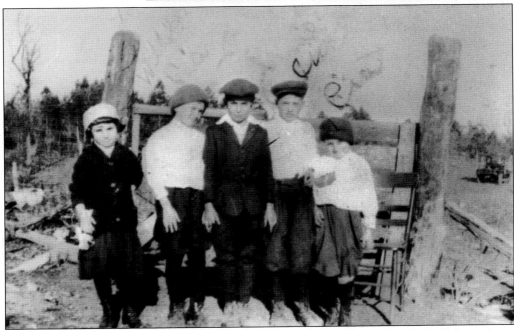

The Cia children (pictured in white shirts)— from left to right, Wilbert, Johnnie, and Mario—pose with Antoniette and Johnny Chiaro (jacket) around 1920. The children were next-door neighbors and, like most of the children in Little Italy at the time, relished any opportunity they had to visit their friends. Note the Ford Model T truck behind the children to the right. (Courtesy of Lenora Newman.)

Luigi Carraro, or "Zio" (Uncle) as his nieces and nephews called him, was a lifelong bachelor who arrived in Arkansas after owning a South American coffee plantation and working in Michigan's iron mines. After arriving in Little Italy, Carraro and his brother Pietro purchased an 80-acre farm owned by Domenico Zulpo in the early 1920s, on which they operated a large pear orchard and factory as well as 30 acres of vineyards. (Left, courtesy of Terry Vanzetti; below, courtesy of Martha Starks.)

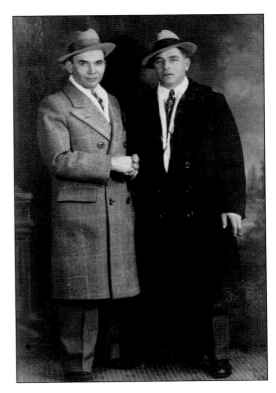

Born in 1889 in Valdagno, Italy, Gelindo Solda (right, in dark coat; left, below) immigrated to Michigan to work in the iron mines in the state's Upper Peninsula. In the early 1920s, Solda followed his friend Ambrogio Vaccari to Arkansas, and the two remained business partners throughout their lives. Solda was a larger-than-life character in Little Italy and wielded tremendous political and economic influence on the region. The other men in the images are unidentified. (Both, courtesy of Loretta Crosariol.)

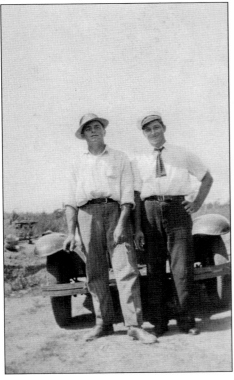

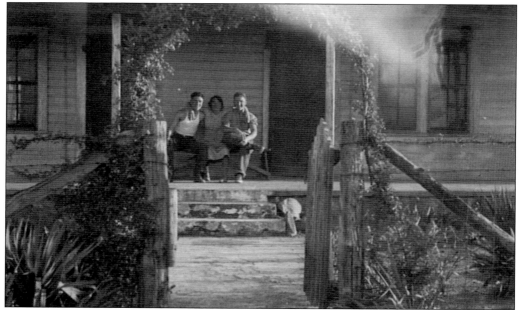

Filomena Crosariol was the only woman to move to Little Italy without her husband, who remained in Chicago to continue working to support the family. Along with friend Pietro Giacometti, she managed the family's farm and raised her children. She exchanged her house in Chicago with the Granato family for the house shown here. Three of the Crosariols' children are seated on the front porch. Tragically, she died in this home in 1939 when tripped by a cat as she walked down the cellar steps, breaking her neck. The home burned in the 1960s. (Courtesy of Loretta Crosariol.)

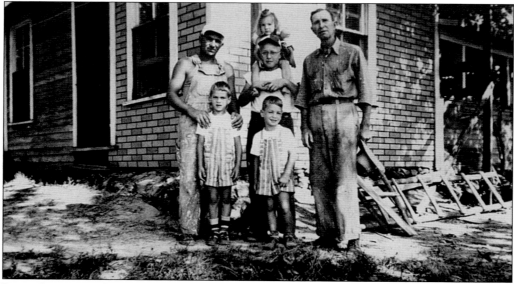

Pietro Giacometti (holding hat) was a bachelor who moved to Arkansas with the Crosariol family in the early 1920s. As the years passed, Giacometti took on the role of father for the Crosariol children and according to the 1930 census, they were mistakenly listed as his children, even bearing his last name. He is shown here with Angelo Crosariol and many of his "adopted" grandchildren around 1949. (Courtesy of Loretta Crosariol.)

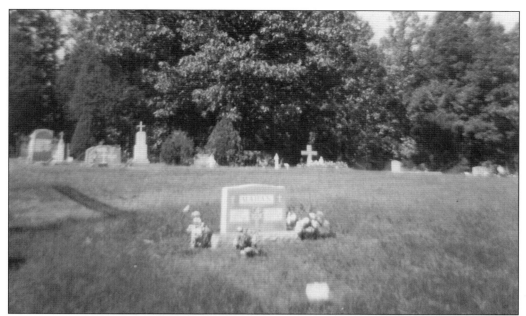

Tragedy struck Little Italy in the summer of 1926 when original settler Antonio Busato and his son Fulvio were struck by lightning while working in the communal cheese house during a thunderstorm. The unfortunate event served as a catalyst for the establishment of St. Francis Cemetery; the two were the first to be laid to rest there after its establishment. John Segalla, the town's patriarch, donated the land for the cemetery, which is situated at the community's highest point. Over 100 individuals have been interred since 1926. Today, the cemetery is one of approximately 50 Catholic cemeteries in the state. (Above, courtesy of Jim Mahan; below, courtesy of the Louis Belotti family.)

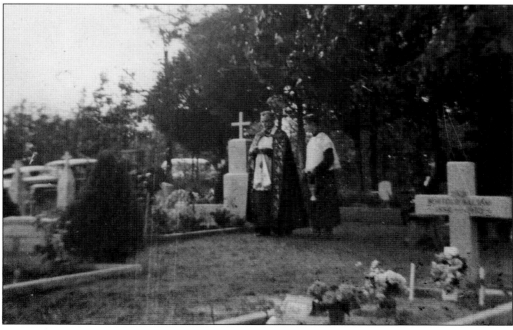

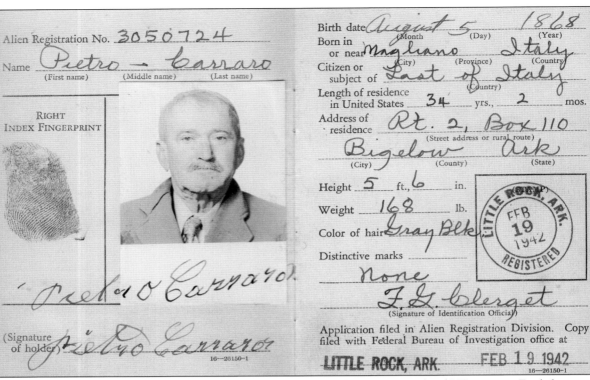

Alien Registration No. _3 0 5 0 7 2 4_

Name _Pietro — Carraro_
(First name) (Middle name) (Last name)

RIGHT INDEX FINGERPRINT

(Signature of holder) _Pietro Carraro_
16—26150–1

Birth date _August 5 1868_
(Month) (Day) (Year)

Born in or near _Magliano Italy_
(City) (Province) (Country)

Citizen or subject of _East of Italy_
(Country)

Length of residence in United States _34_ yrs., _2_ mos.

Address of residence _Rt. 2, Box 110_
(Street address or rural route)

Bigelow _Ark_
(City) (County) (State)

Height _5_ ft., _6_ in.

Weight _168_ lb.

Color of hair _Gray Blk_

Distinctive marks _none_

F. G. Clerget
(Signature of Identification Official)

Application filed in Alien Registration Division. Copy filed with Federal Bureau of Investigation office at

~~LITTLE ROCK, ARK.~~ FEB 19 1942
16—26150–1

Many of the immigrants who settled in the area never became naturalized US citizens. English proved to be extremely difficult for the older generation, many of whom lacked formal education altogether. They relied on their children to help them conduct business because of their limited vocabulary. For years, the federal government overlooked the immigration status of Little Italy's residents, but with the onset of World War II, xenophobic attitudes against Germans, Italians, and Japanese immigrants led to a greater level of scrutiny for those groups. In the early 1940s, several of the area's residents received letters from governmental agencies threatening deportation if they could not prove long-term residency. Individuals sought legal counsel, signed affidavits verifying their residency, and obtained alien registration cards such as the one seen here for Pietro Carraro. (Courtesy of Martha Starks.)

Two

Labor, Farming, and Business

A sense of community enterprise permeated the atmosphere established by the Little Italians. In the town's vineyards and orchards, everyone was expected to cultivate his or her crops to ensure the markets he or she supplied received quality produce at reasonable prices. Like a cooperative, the farmers ensured their mutual success through a common goal of commercialized grape operations and producing wine in mass quantities. This pooling of the farmer's resources made it possible for companies to send freight cars to nearby Ledwidge to ship the colony's goods. This cooperative effort allowed 35 railcars of grapes, 30 cars of peaches, and 10 cars of apples to be shipped each year to surrounding markets and beyond. In a 2002 interview, Louis Carraro, whose family owned 30 acres of vineyards and a 30-acre pear orchard described the process as follows: "We used to sell grapes in eight-pound baskets. We'd load them up on a wagon and carry them to Ledwidge on a team of mules. We'd get down there and they'd load them up on boxcars with ice compartments . . . We used to haul the grapes to the curb market . . . We'd haul sacks of pears, potatoes, and watermelons." Though the settlement's farmers operated independently and were fiercely competitive, each understood that they were all dependent on each other to grow enough produce to attract the attention of the myriad of vendors to which they sold their goods. This communal conglomerate extended not only to the sale of fresh fruit but also to the wine sold by the settlement's four wineries as well.

Aside from agricultural endeavors, few commercial establishments existed in Little Italy. Through the 1950s, there were at least three places from which basic necessities could be purchased, though the residents often purchased their groceries from nearby towns. In addition to general stores and taverns, there were a few dance halls over the years that served as sources of income for their owners.

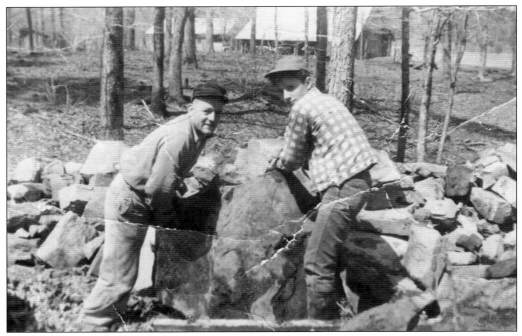

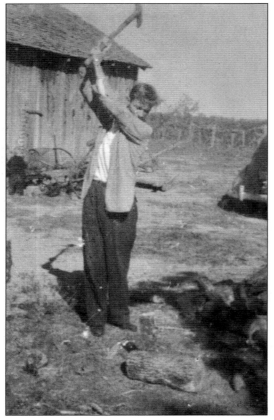

Agricultural endeavors proved to be extremely difficult for the area's inhabitants. The severe slopes and rocky, mountaintop soil offered little possibility for profit. One method that was commonly used to combat both of these issues was the construction of terraces using the stones turned up by recent plowing. For example, some of the three levels of terraces built by the Belotti family were nearly six feet tall by four feet wide and collectively stretched for miles. (Courtesy of Eda Segalla.)

Wood-burning stoves warmed homes and provided families with a source of heat with which to cook. Cutting and hauling wood were among the many chores routinely performed by the community's young men. Louis Carraro, seen here chopping wood as a teenager at his parent's home, recalled in 2002, "It was my job to get in kindling and carry in stove wood at night for my dad. He'd get up early . . . and start a fire. That's the only source of heat we had was in the kitchen . . . That's where everybody gathered. They'd sit in the kitchen, play cards, drink coffee." (Courtesy of Martha Starks.)

Knowledge in woodworking and construction were necessary skills for the men of Little Italy. Many men harvested timber and milled their own lumber for the numerous general maintenance projects around their homes. Many men helped neighbors with renovations or volunteered their time to help maintain the church or other public buildings in the community. (Courtesy of Olga Dal Santo.)

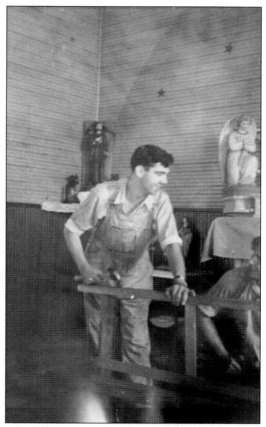

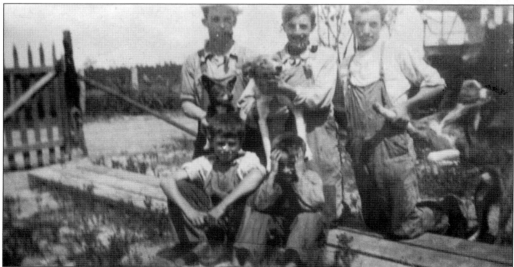

After their father died in the fire that consumed the family's home, the teenaged Belotti boys rebuilt the home for their mother. The brothers used their ingenuity to construct the home despite their limited formal education or construction training. The home still stands in Little Italy as a testament to their craftsmanship. (Courtesy of the Louis Belotti family.)

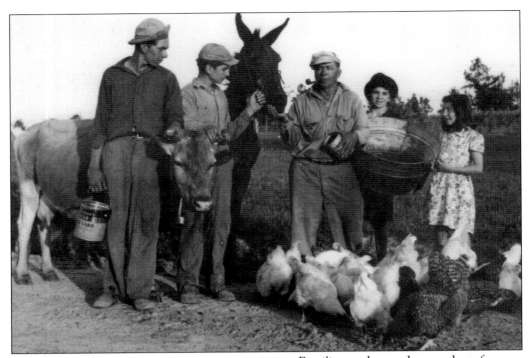

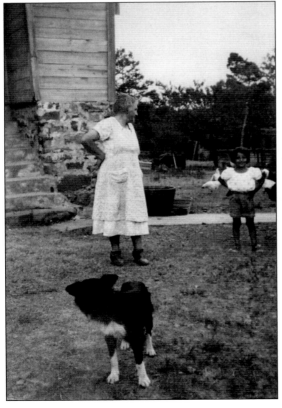

Families used secondary products from their livestock on a daily basis. For example, cattle provided milk, which was consumed alone or was turned into cheese or butter. Every family had numerous hens, and eggs were gathered daily from the chicken coops. Chicken litter was used as fertilizer for vegetable gardens or vineyards as was the manure of many other animal types. At left, numerous chickens are seen behind the child in Maria Balsam's yard. (Above, courtesy of Lenora Newman; left, courtesy of Joann Janssen.)

In addition to using their livestock for secondary products, animals like pigs, cows, and chickens were sometimes slaughtered for their meat. Meat was not part of the Italian's daily diet, but instead was eaten only occasionally. The Carraro family is shown butchering a calf, which was a time-sensitive process before electricity and refrigeration became available. The butchering was done quickly before the meat spoiled; to preserve the beef, it was canned. (Both, courtesy of Martha Starks.)

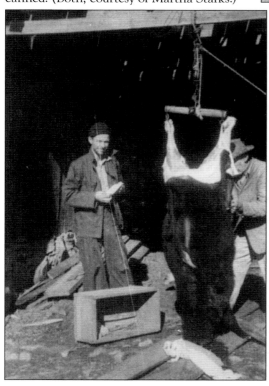

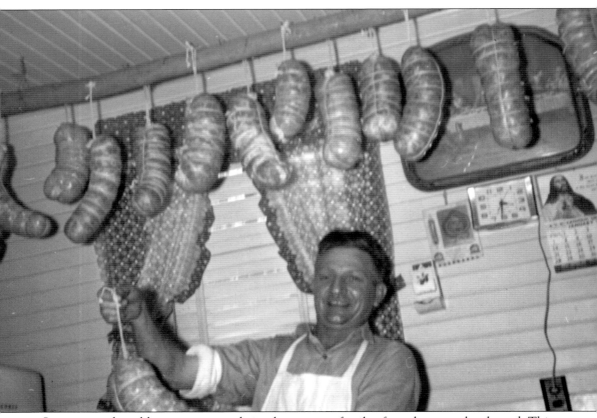

Sopressa, a salami-like meat, was made in almost every family after a hog was slaughtered. This practice usually occurred in the winter to ensure the meat would not spoil in the summer heat. After adding several spices to coarsely ground pork, the mixture was stuffed into a large, natural casing, usually the pig's stomach. The casing was punctured, and the meat was hung to allow it to drip-dry in the cellar for a few months before it was totally cured and ready to eat. A thin mold usually developed on the outside of the meat, signaling it was ready for consumption. John Segalla is shown hanging his sopressa in the kitchen for the initial drip stage before it is transferred to the basement. (Courtesy of Eda Segalla.)

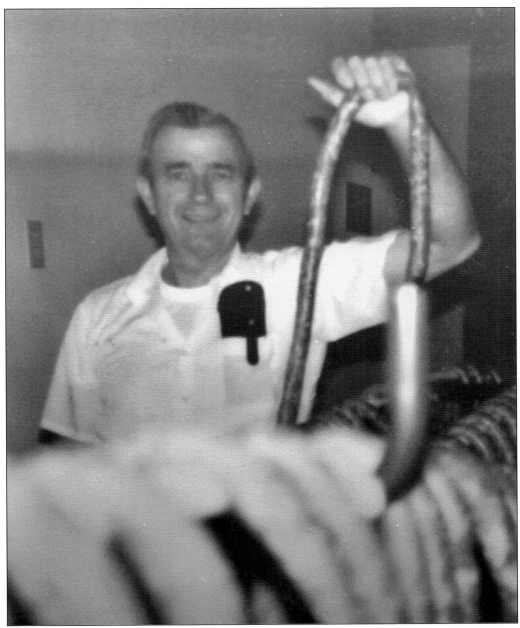

Like sopressa, sausage was also a staple pork product regularly produced in Little Italy. Various family recipes existed for the sausage, but it mostly consisted of pork, salt, and pepper. Sometimes, other spices were added. The sausage was produced in a similar way to the larger sopressa, though pork intestines were used as the casing. The sausage was hung and dried for a few days before it was eaten. Many cooked the sausage and then stored it in large cans of lard for later consumption. (Courtesy of Olga Dal Santo.)

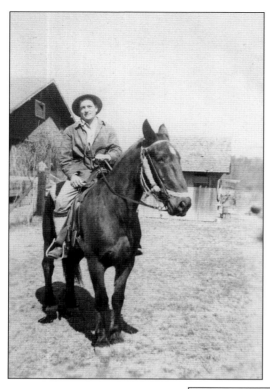

Donkeys, horses, and cattle were necessary livestock for successful agricultural endeavors in Little Italy. These beasts of burden performed countless hours of work for their owners and were often considered part of the family. This close relationship with animals was not new to the immigrants. As children in Italy, they lived in homes in which the bottom level contained the animal's stables. In the wintertime, the animal's body heat radiated through the floors above, thus warming the humans. (Courtesy of Angela Petursson.)

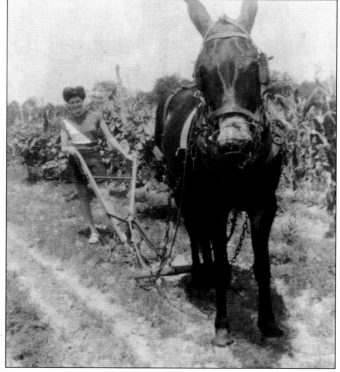

Mules, like the one seen here with a member of the Zulpo family, bore the brunt of the colony's agricultural labor. The animals pulled plows, dragged boulders to build terraces, and provided families with reliable transportation. Joseph Belotti, who died in a house fire in 1929, valued the animals so much that, as he alerted his family to get out of the burning house, he reminded them to save his prize mules Jim and Mandy too. (Courtesy of Lenora Newman.)

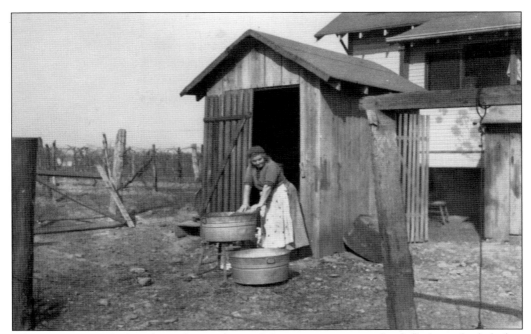

Like most women before the widespread use of electricity, women in Little Italy washed clothes by hand using large wash buckets and washboards. These buckets were also used for bathing and to cut down on the amount of labor to gather and heat the water; bathing was limited to once a week, and family members often bathed in the same water. (Courtesy of Rico Belotti.)

Lucy Granato was born in Arkansas before she and her family returned to Chicago not long after her birth. The infant is shown here getting bathed on the back porch of her parent's home, around 1922. (Courtesy of Roger Rossi.)

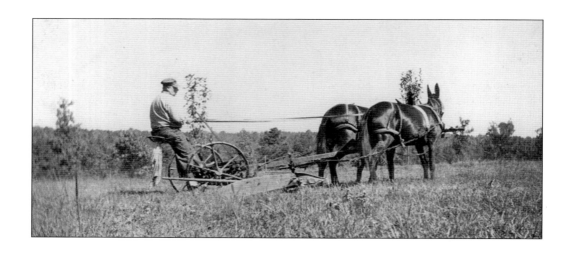

Mule-drawn mowing machines were necessary implements farmers used throughout the community. In this series of photographs, John Zulpo is seen cutting hay while his children load the raked hay onto a cart using large pitchforks. After cutting and allowing it to dry, a hay rake was attached to the mules, and the cuttings were gathered into piles before being loaded onto a cart bound for the family's barn. Once the hay was stored in the barn, it was stomped to compact it, which allowed for more hay to be added. (Both, courtesy of Lenora Newman.)

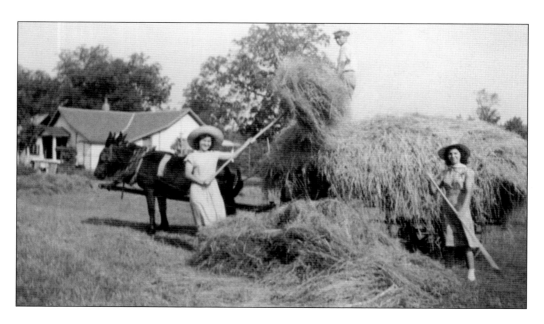

Little Italy's farmers spent far more time in their vineyards and barns than they did in their homes. Possessing large tracts of land on which numerous structures could sit was not common in Italy during the era in which these immigrants were born. Here, Pietro Carraro is flanked by his barn in the 1920s. The structures were a source of pride for their owners because they were manifestations of the family's success and a symbol of their land holdings. (Courtesy of Martha Starks.)

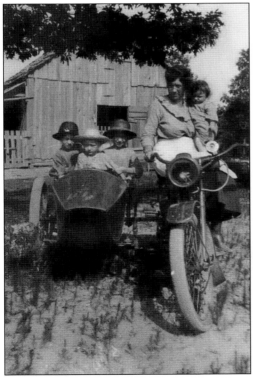

Like most of the barns in the community, the Vaccari family's barn (shown in the background) was built with primitive, self-milled lumber. Often, whole tree trunks were hewn and aged to serve as support posts or beams for barns and houses alike. Cedar posts were typically used for this type of construction because of the wood's density and resistance to rot. (Courtesy of Olga Dal Santo.)

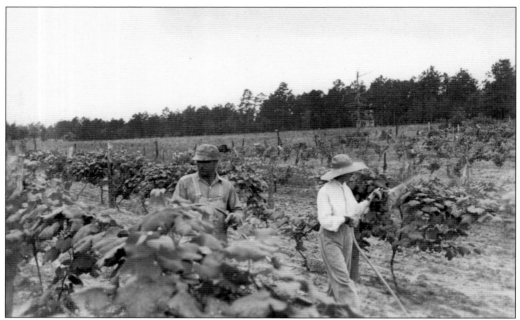

More than 200 acres of grape vines speckled the countryside of Little Italy. Each year, the area produced upwards of 30 railcars filled with grapes destined for local markets, a third of which were sent as far away as Kansas City, Missouri, while processing thousands of gallons of wine as well. (Courtesy of the Arkansas History Commission.)

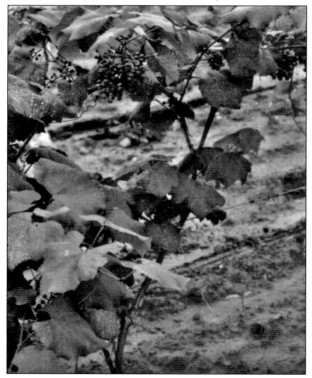

Concord grapes were the most common variety of grapes found in the local vineyards, but other varieties such as Riesling and Corinth grapes were grown as well though in lesser quantities. Many of the grape vines were brought to America as cuttings from vineyards in Italy. The July 23, 1927, *Guardian,* the newspaper of the Catholic Diocese of Little Rock, reports the following: "They find that these Arkansas hills are the best for grapes and fruits, especially grapes, they have seen since they left Italy." (Courtesy of the Arkansas History Commission.)

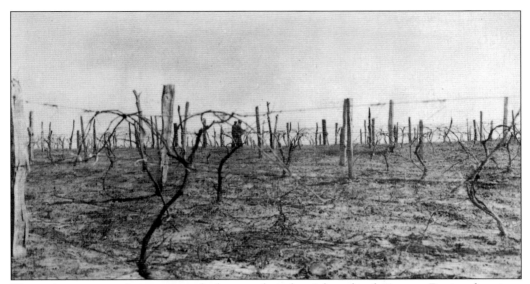

Harvesting grapes took approximately three weeks in late July and early August. During that time, all members of the family were required to work in the vineyard. Outside of the busy spring and summer months, the vines required little attention. The vines are seen here in the late winter months just before they began to sprout buds for the spring. (Courtesy of Jim Mahan.)

During the spring, the air in Little Italy was filled with the scent of the small, white blossoms that bloomed from the vines. In the 1920s, this dapper young gentleman poses in front of the blooming vines, which was a common Easter practice throughout the community. Note the boutonniere on his left lapel. (Courtesy of Jim Mahan.)

47

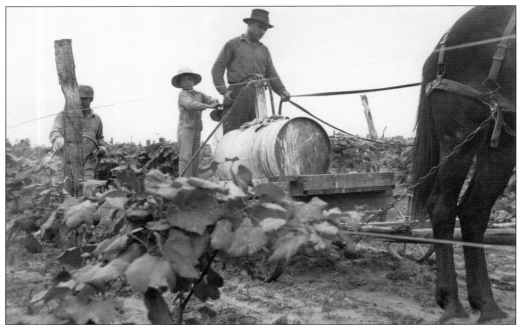

During the growing season, the vines were sprayed four times with a fungicide to prevent mildew infestation. The fungicide, called Bordeaux mixture, contained an insecticide called arsenate of lead, copper sulfate, lime, and water. The vines were sprayed before budding, before blooming, and twice after the grapes formed. Two weeks before harvesting occurred, the final spray was applied; it contained a cleansing agent of fish-oil soap mixed with the other additives. Ironically, despite this annual preventative measure, it was a fungal mildew blight that eventually diseased the vines and led to the closure of the commercial wineries in the 1950s. (Both, courtesy of the Arkansas History Commission.)

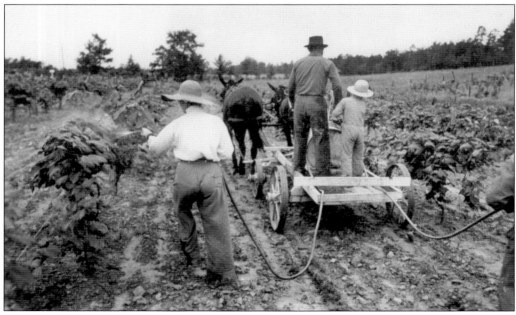

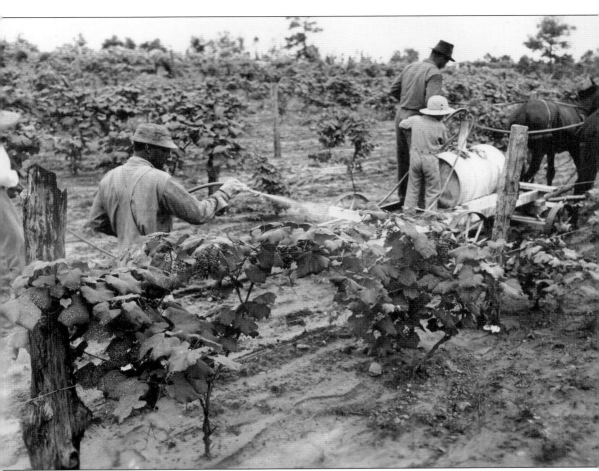

Sperandio Ghidotti's vineyard, shown here, comprised half of his 80-acre farm. Some 12,000 grape vines produced 6,000 baskets of grapes that were aesthetically acceptable to sell at market, while an equal number, if not more, went into producing wine. Ghidotti and his son Angelo (adult on wagon) operated Arkansas Bonded Winery No. 2 after Prohibition ended. (Courtesy of the Arkansas History Commission.)

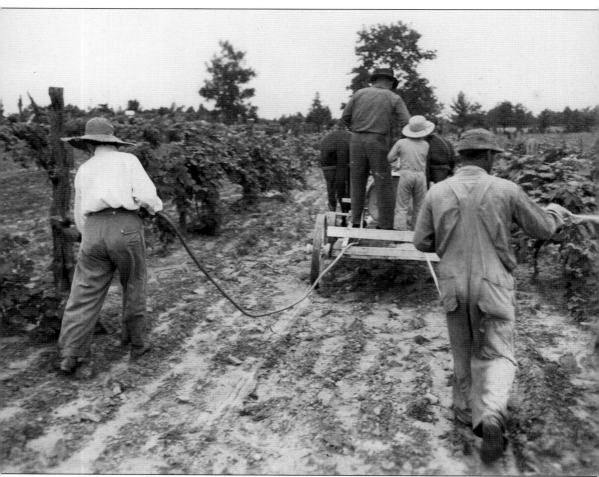

During the Depression, the Work Projects Administration (WPA) chronicled the history of the states through the American Guide Series. As part of Arkansas's guide, writers and photographers visited Little Italy and captured these images of farmers spraying the vines at Ghidotti's vineyard. In the guide, the WPA authors remark, "Little Italy . . . an agricultural community of Italians who came from Chicago . . . A white church with a pointed steeple on a hilltop marks the center of the settlement. Long rows of grape vines descend the slopes toward the Fourche la Fave River and the Arkansas, and there are bonded wineries in the community. Well-cultivated cornfields and cotton fields among the vineyards give the colony a refreshing air of prosperity." (Courtesy of the Arkansas History Commission.)

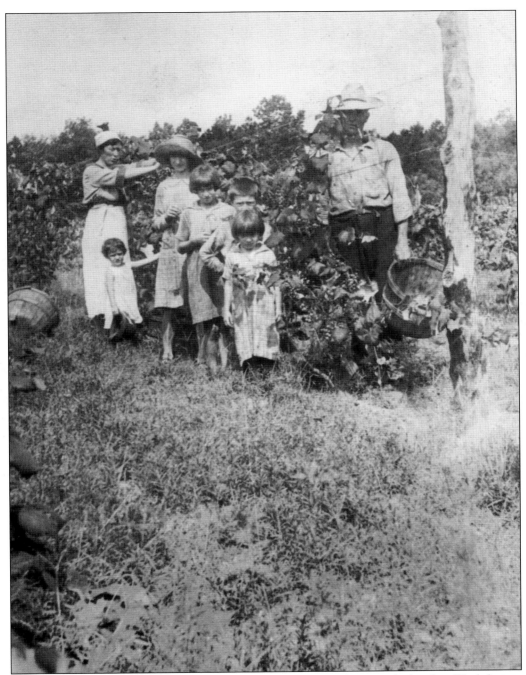

The Vaccari family tends their grape vines during the summer of 1927, at the height of Prohibition. In the photograph, each member of the family has a bucket to fill with grapes—down to the youngest child, just two years old at the time. Working in the vineyard was expected of every member of the family. The Vaccaris' eldest daughter Irma (pictured with a hat in the row of children) once recollected, "Picking the grapes was a hot thing too. My father would say, 'Look it! See, you don't need rouge! Look at how nice and red you are!'" (Courtesy of Barbara Penney.)

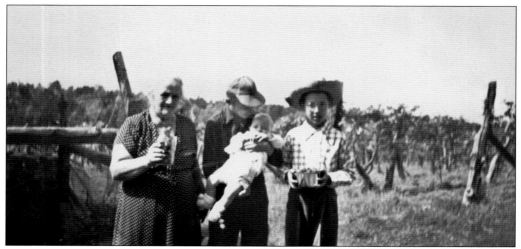

During Prohibition, grapes from Little Italy were packed and sold in bushels or illegally processed into wine or cognac. Antonia Ghidotti's grandson Joseph (straw hat) is shown holding a pint-sized basket of grapes, which were shipped to nearby grocery stores. Ghidotti is holding a canning jar filled with grapes as well, more than likely for personal consumption. (Courtesy of Eda Segalla.)

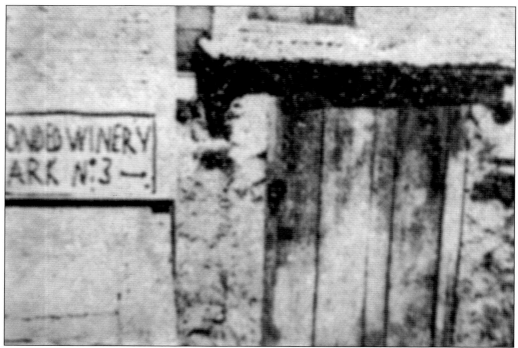

John and Lucia Segalla's vineyard occupied about 20 acres surrounding their home, in which Arkansas Bonded Winery No. 3 was located. The vineyard produced thousands of gallons of port and claret wine yearly, despite the fact that it was located in a dry county. This means that, after Prohibition, a vote was taken in Perry County to prohibit alcohol sales within its boundaries, though Segalla continued to sell wine well into the 1950s. (Courtesy of Lenora Newman.)

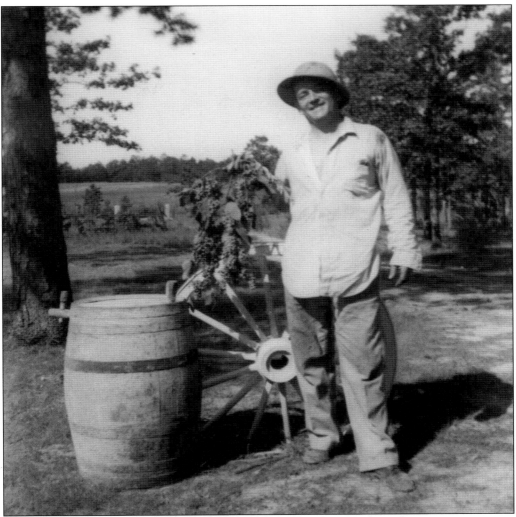

Wine or cognac was stored in barrels, such as the one pictured here with Louis Belotti, shown proudly displaying grapes from his vineyard. In a 1990 self-recording, Belotti stated, "We made wine . . . somebody'd say that the Sheriff was coming and raid your place . . . We'd roll these barrels down in the woods and hide them under the brush. And when they'd pass us over, then we'd roll them back into the basement. We had to make Moonshine, but they called it cognac, just to make a living . . . that's how we got along." (Courtesy of the Louis Belotti family.)

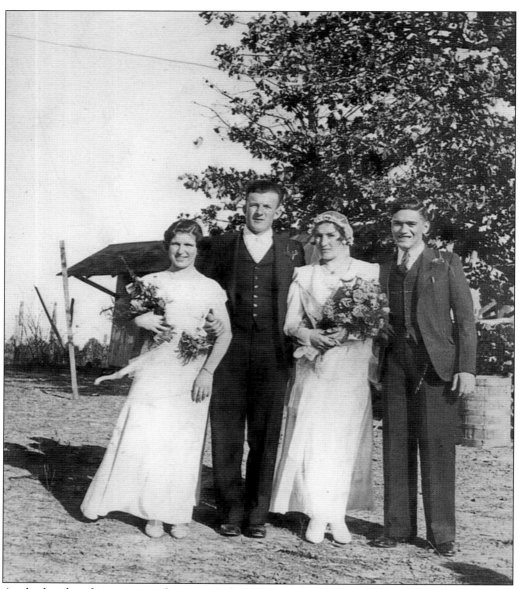

At the height of its wine production, Little Italy boasted four bonded wineries that produced thousands of gallons of wine each year. A 1936 advertisement from the *Guardian* indicates that John Segalla and Sperandio Ghidotti joined forces to craft the "finest wine produced in Little Italy." According to an interview with Ghidotti in the August 9, 1931, edition of the *Arkansas Gazette*, he owned 60 acres of grapes, 12,000 grape vines, and produced 6,000 baskets of grapes each year. For the Ghidottis, it was a family affair; Sperandio Ghidotti said, "We all work to get them in off the vines when they're ripe—my son Angelo, my daughter Katherine, my two little girls, myself and my wife." The winery truly was a family affair for Ghidotti, because by the time this ad was printed, the two men had more in common than simply wine: Segalla's son Americo wed Ghidotti's daughter Katherine, and a short time thereafter, John Segalla Jr. married Louisa Ghidotti. Americo and Katherine are pictured (center) on their wedding day in the early 1930s. Also pictured are Geneva Renda and Johnnie Cia. (Courtesy of Katie Segalla.)

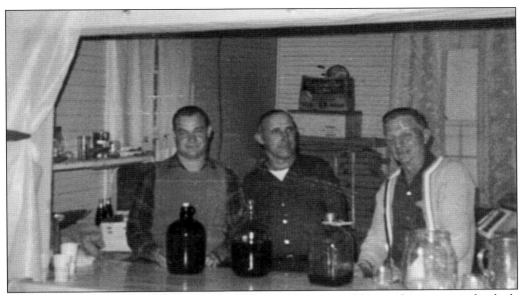

Instead of perusing a vast selection of prebottled wine like one would in modern stores, individuals who purchased alcohol from one of the wineries in Little Italy watched as the proprietor filled assorted bottles with the desired amount of wine at the time of the sale. Barrels of wine were stored in cellars, and upon request, the alcohol was drawn from the tap and sold in varying amounts. From left to right, Franklin Zulpo, Angelo Ghidotti, and Johnny Segalla are seen with one-gallon wine jugs, none of which matches the others. (Courtesy of Loretta Crosariol.)

Once the production and sale of alcohol was legalized after Prohibition, many families registered for permits to produce wine for sale and personal use. This certificate, issued to Vincent Chiaro, authorizes the production of 1,000 gallons of wine between January and July 1934. This amount of wine placed Chiaro in the middle tier of producers in the settlement. His operation was not large enough to be considered a winery, yet it was too large for private consumption. Chiaro likely used this wine to supply his popular weekend dance hall. (Courtesy of the John Chiaro family.)

DEPARTMENT OF REVENUES
State of Arkansas
PERMIT TO MANUFACTURE,
SELL AND CONSUME WINE.

ORIGINAL – Annual Number B-17

Class B Fee Paid $ NONE

THIS IS TO CERTIFY, that James Chiaro
 Route #2, Box 115
 Street No. or R. F. D.

 Bigelow, Arkansas,
 Post office
(James Chiaro
 Name and address of owner, or owners if not a corporation
)

having complied with all the requirements of Act No. 4 of the Special
Session of the General Assembly approved January 12, 1934, is hereby
authorized and permitted to make or manufacture wines and dispose of
them as follows:

Class A

Class B Permit (Permit to Manufacture Not More than 1,000 gallons)

Class C

for and during the fiscal year ending June 30, 1934.

 IN TESTIMONY WHEREOF, I have hereunto set my hand and affixed
the seal of —— Department of Revenues this 3rd day of February 1934

 EARL R. WISEMAN
 Commissioner of Revenues

 By Paul Summers.

EXPIRES
JUNE 30, 1934

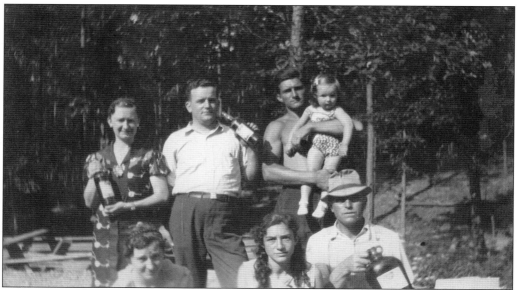

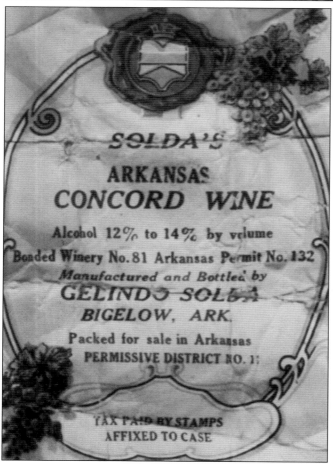

Gelindo Solda (hat) and his godchildren display the numerous varieties of wine he produced at his winery in the early 1940s. The labels on the bottles they are holding are like the one pictured at left. The most common variety of wine produced in Little Italy was Concord wine. This wine was relatively sweet, which catered to the American palate better than dry varieties. Solda marketed and sold his wine at the tavern he co-owned with the Vaccari family. Visitors were met by two large signs, which advertised "Wine for Sale." Dozens of signs for products ranging from beer and tobacco to Coca-Cola adorned the exterior wall of the tavern as well. (Above, courtesy of the Louis Belotti family; left, courtesy of Barbara Penney.)

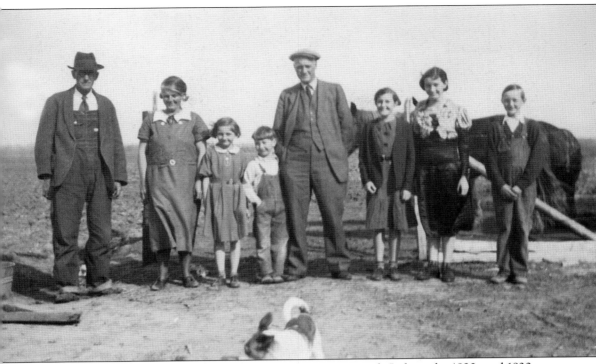

Each weekend, central Arkansans made the grueling trip to Little Italy in the 1920s and 1930s to purchase alcohol. Many visitors also came to the area for the rare chance to get authentic Italian cuisine because of the limited restaurant offerings in Little Rock at that time. Here, a group of well-dressed patrons poses during a visit, which likely included a meal and at least a few bottles of wine and moonshine. (Courtesy of Jim Mahan.)

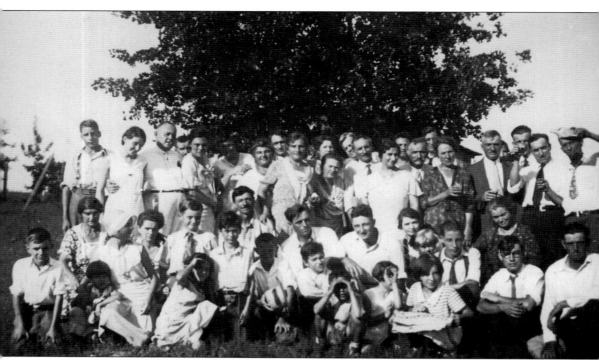

Average citizens were not the only pilgrims to the wine-producing oasis during Prohibition. In the 1930s, at the height of Prohibition, Arkansas state legislator Paul Van Dalsem (standing, third from left) poses with his constituents, some of whom boldly display their libations for the camera. Van Dalsem represented the district in Pulaski and Perry Counties for many years until 1967, when he famously stated that women in his district stay out of politics by being kept barefoot and pregnant. He lost the subsequent election. (Courtesy of Jim Mahan.)

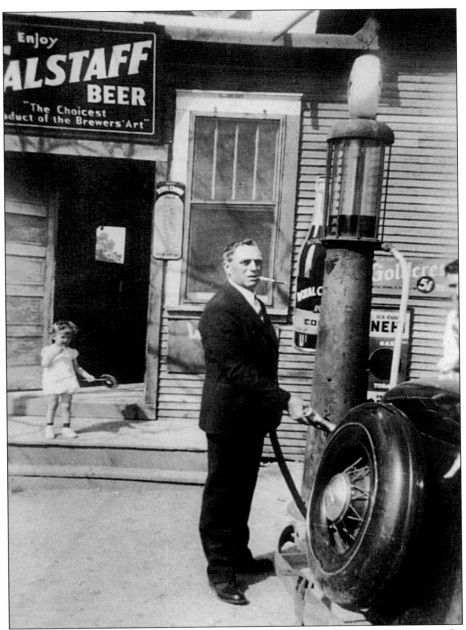

Most of Little Italy's wineries were cash-and-carry operations with little or no amenities for their patrons aside from the liquor being purchased. One business that bucked the trend was Gelindo Solda's "beer joint," where gasoline, Falstaff beer, tobacco, candy, and other items were sold. Solda co-owned the tavern with business partner and friend Ambrogio Vaccari. In addition to serving as a local store, the pub was visited by high-ranking state politicians, many of whom became Solda's friends and offered political favors in return for clean liquor. During Prohibition, these influential friends pulled numerous strings for many of the producers of cognac and wine in Little Italy so that they could continue making alcohol without fear of prosecution and imprisonment. (Courtesy of Olga Dal Santo.)

Men from the surrounding towns of Wye, Ledwidge, Bigelow, and Roland made up a majority of the beer joint's patrons. In addition to the vast quantities of alcohol, customers listened to music from a nickelodeon, danced with local women, and played bocce (yard bowling) on the court located behind the store. The tavern gained a reputation for being a hot spot for brawls and drunken violence because of the large amounts of alcohol consumed there. Olga Dal Santo reminisced in 2001, "Everyday there'd be someone come in and play the nickelodeon. They'd have fights you know, at the beer joint. They'd get drunk and fight. Boy, I've seen a lot." (Both, courtesy of Olga Dal Santo.)

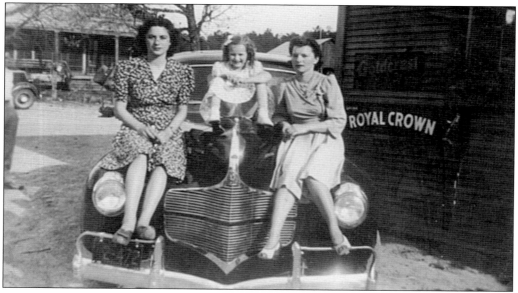

Three

Everyday Life and Culture in Early Little Italy

The daily activities of those living in early Little Italy varied little from other farmers in Arkansas at the turn of the 20th century. Subsistence farming dominated the lives of the settlers, and every activity was carefully calculated to determine its overall benefit to the household. Gender and age determined what activities were assigned to individuals, but all family members were expected to participate in one way or another. Families typically included between eight to ten members; children in some families ranged from newborn to 20 years old.

While men undertook most of the tasks related to business, planting, and farm maintenance, women oversaw all aspects of the domestic sphere. They baked at least three times a week, cared for children, and prepared daily meals for their families. Doctors were only sought in emergencies, so some women were known throughout the community for concocting salves and tonics to treat ailments of all sorts. A few women served as midwives, and some even believed they could predict the sex of an unborn child with uncanny accuracy.

After a day of hard work, members of the small community relaxed in a variety of ways. Musicians played instruments like the accordion to provide hours of entertainment for community-wide dances. Men played bocce and consumed copious amounts of alcohol and tobacco at local beer joints or wineries to wind down. Women visited each other, sang while playing the tambourine, and joined the men in playing traditional card games such as briscola or tresette in the evenings. Children swam in a local creek, hunted, and played games after attending classes at the Ledwidge schoolhouse and finishing their chores at home.

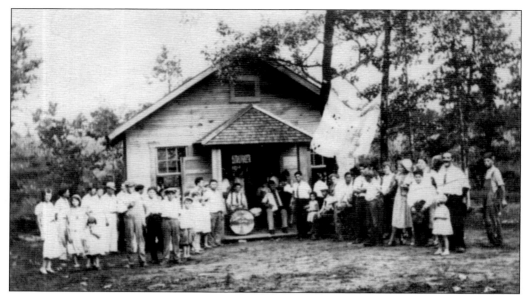

Vincent and Annunziata Chiaro were proprietors of a dance hall that featured a small bar and music by some of Little Italy's most promising musicians. Before the widespread use of radio and prior to the arrival of electricity to the area, it was not uncommon to hear traditional Italian music bellowing from accordions whether it be at the Chiaro dance hall, the Solda beer joint, or at St. Francis Church. Here, in photographs taken only a few moments apart, a large group of merrymakers is enjoying the sound of the Little Italy Orchestra, as owner Vincent Chiaro (above, second from right and fourth from the right below) looks on with delight. (Above, courtesy of Lenora Newman; below, courtesy of the John Chiaro family.)

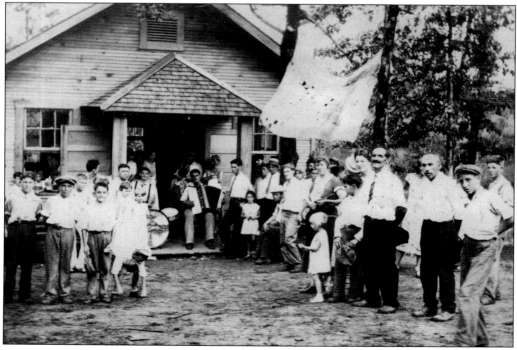

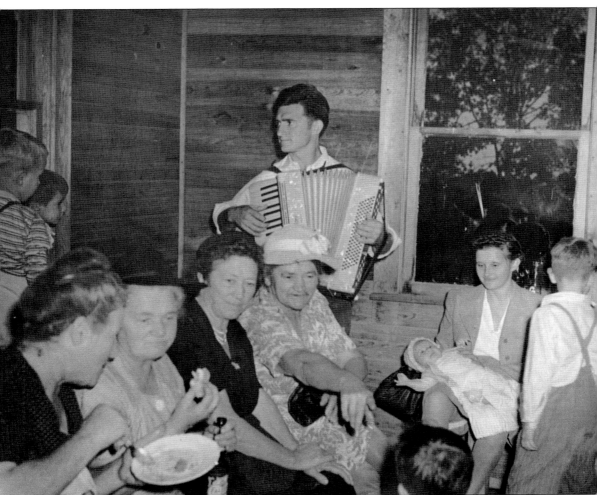

Every Saturday evening, members of the community gathered to drink, dance, gossip, and listen to music. The crowd ranged from young to old, but all enjoyed themselves, no matter their ages. This event, which took place at St. Francis Church, attracted many of the older residents, their children, and grandchildren. While Raymond Vaccari plays the accordion, (seated, from left to right) Maria Zulpo, Verina Cia, Angela Vaccari, Carlotta Carraro, and Louisa Segalla listen to the music while gossiping and watching children play. (Courtesy of Katherine Siegman.)

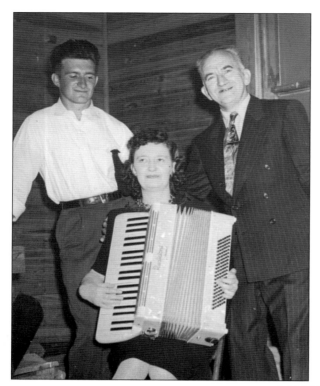

Music was an integral part of life in Little Italy. Irma Vaccari Belotti (center with accordion) played the organ at St. Francis Church for over 70 years. The June 28, 1930, edition of the *Guardian* newspaper reports, "The children's choir of St. Francis rendered Latin and Italian hymns during the administration of confirmation. The choir was under the direction of Miss Erma Varcarri [*sic*], the organist." Though she primarily played piano and organ, Belotti was a talented musician who passed her love of music on to her children and grandchildren. (Left, courtesy of Katherine Siegman; below, courtesy of Anita Wagner.)

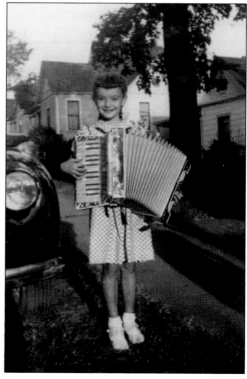

Just as music played a key role in the culture of Little Italy, dancing was also a favorite pastime among locals and visitors alike. Because the local men were often in Little Rock and surrounding areas working, the settlement's dance halls would often be filled with Italian women and American men from surrounding towns who gladly paid the nickel or dime cover charge to have access to liquor, women, and dancing each Saturday night. (Courtesy of the Louis Belotti family.)

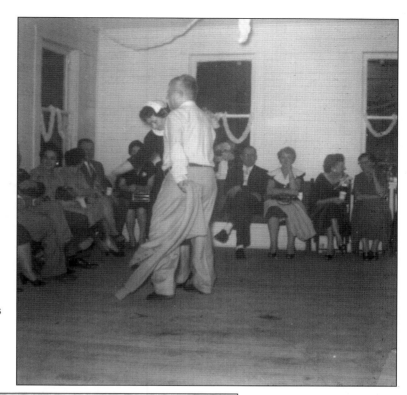

LITTLE ITALY

Italian Colony
(LEDWIDGE)

H O L D S

ANNUAL FALL PICNIC

Evening of Sept. 11 and ALL-DAY, Sept. 12

**SPECIAL DINNER ALL AFTERNOON
PRICE 35c**

"BRING YOUR FRIENDS"
Benefit St. Francis Building Fund

DANCE

Saturday Night, Sept. 11
MUSIC BY LITTLE ITALY ORCHESTRA

Dancing also played an integral part in the community's annual grape festival. The two-day event included dancing on Saturday night, which often occurred on an open platform. The bazaar attracted people from throughout Arkansas who came to dance, drink, and camp out before the next day's festivities. (Courtesy the *Arkansas Catholic* Archives.)

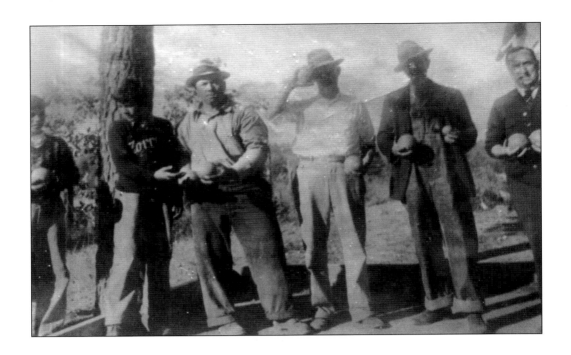

The residents of Little Italy played bocce at every opportunity, because a friendly competition on the bocce court was a great way to socialize and enjoy spirited conversation. The object of the game is to throw heavy balls as close as possible to a smaller target ball within a flat, rectangular, chat-filled court with backboards. Wagers would often be made between competitors to make the game more exciting. In 2002, Louis Carraro reminisced, "We'd choose sides and the losers would buy the beer. Oh, we had a big time, it was great. Every weekend. Man, we used to take that seriously." (Above, courtesy of Olga Dal Santo; below, courtesy of Lenora Newman.)

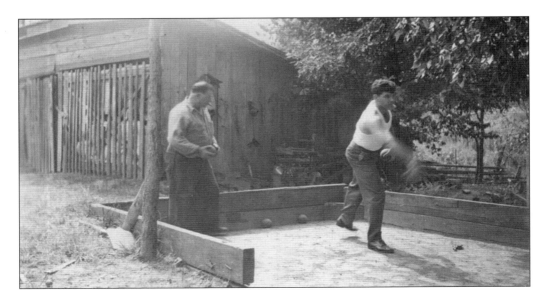

Four bocce courts were situated throughout the community. At James and Verina Cia's store, customers could buy beer and play bocce on the court behind the establishment. Their son Harry is seen on the court with a group of men playing behind him. (Courtesy of Loretta Crosariol.)

Though men normally played bocce, occasionally women played as well. In this action shot, Malia Belotti pitches the ball in an attempt to get her ball the closest to the jack, or the smaller target ball, which is the focal point of the game. (Courtesy of Angela Petursson.)

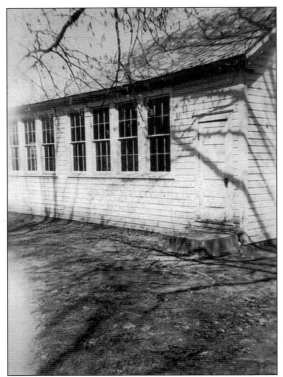

The local schoolhouse was situated approximately a mile away from both communities it served—Ledwidge and Little Italy. The school was part of the Perry County District, though like all small schools at the time, it operated somewhat independently from the other area schools. At the height of its enrollment during the late 1910s, the one-room school served over 70 pupils in grades one through eight, with only one teacher. (Courtesy of Loretta Crosariol.)

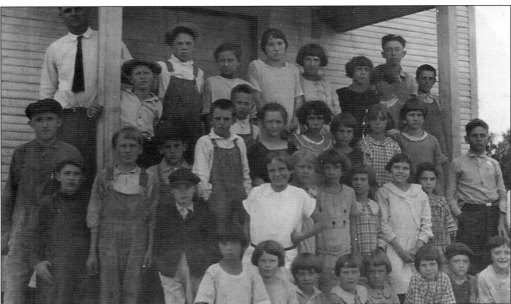

Carl Adams (wearing necktie) was one of the many teachers who taught at the Ledwidge School before it closed in the 1940s due to consolidation laws. Prior to that time, Arkansas had over 5,000 school districts, essentially one for each small town in the state. Adams was known as an especially ruthless disciplinarian, and many of the Italian students felt that he unfairly mistreated them because of their cultural differences. (Courtesy of Roger Rossi.)

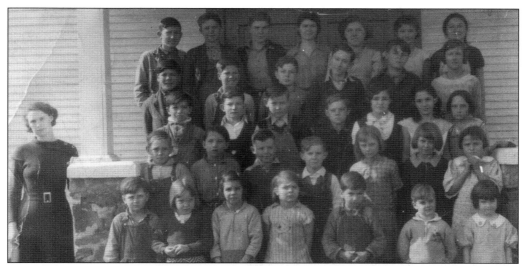

The teachers at the school made every effort to Americanize the Italian students enrolled in their classes. For example, Italian names were often changed to more American-sounding names. Brunetta Vaccari (fifth row, far right) was forced to change her name to Bernice because her teacher could not pronounce her given name. (Courtesy of the Louis Belotti family.)

Department of Education
State of Arkansas

Whereas, *Antonia Belotti*, a Student in the *Ledwedge* Public School in the County of *Perry*, has completed the course of study prescribed for the Common Schools of the State of Arkansas and is entitled to enter any High School in the State.

Now therefore, This **Pupil's Certificate** is granted to *her* as an evidence of the fact that by regular attendance, orderly deportment and satisfactory scholarship the right to such recognition has been attained.

WITNESS OUR HANDS AND SEAL OF THE DEPARTMENT OF EDUCATION OF THE STATE OF ARKANSAS THIS *23rd* DAY OF *May* 1950

Homer Dudson
COUNTY SUPERINTENDENT

Jesse Jones
TEACHER

C. M. Hirst
STATE SUPERINTENDENT

Female students typically attended through the eighth grade, while boys might only attend through the third or fourth grade to enable them to help on the farms. Once the students graduated from eighth grade, they were entitled to attend Joe T. Robinson High School approximately 20 miles away. Because of the distance, few pupils chose this option; those who did were usually females. Antonia Belotti's eighth-grade diploma from the Ledwidge School is shown here. (Courtesy of Jim Mahan.)

The 1930s and 1940s were a baby boom of sorts for the community. Scores of children were born to the children of the original settlers. Like their parents, this younger generation experienced numerous hardships and were expected to participate in the day-to-day operations of the settlement's farms. Like typical grandparents, the older residents of Little Italy took tremendous pride in their grandchildren. Named for both of his grandfathers, Vincent Sperandio Chiaro is shown on his father's automobile, around 1942. When Chiaro (left) was born in January 1940, his maternal grandfather, Sperandio Ghidotti, walked more than a mile through the snow to see his newborn grandson. (Both, courtesy of the John Chiaro family.)

Angelo Zulpo, seen holding his daughter Frieda, and his wife, Jennie, married in the late 1920s. They had 10 children over a span of 25 years. Brothers John and Angelo Zulpo were their parents' only children, yet they combined to have nearly 20 children between them. Because of this, the Zulpo name became one of the most prominent in Little Italy. (Courtesy of Angelina Dunlap.)

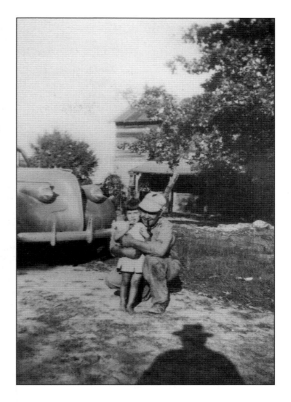

Louis Belotti and his daughter Angela are seen in the late 1930s on the dirt road that ran through the settlement. Built and maintained by the local residents, the road eventually became Arkansas Highway 300. (Courtesy of Angela Petursson.)

One of the most common forms of recreation enjoyed by people of all ages was conversation. In the cooler evening hours, families often visited neighbors and enjoyed discussing the day's events on the front porch. Typically, the hostess offered wine to her visitors; to decline this offer was considered incredibly rude. After toasting "Salute!" the conversation carried on well into the evening. Children joined their parents on these visits and found their own forms of entertainment while the elders looked on. Older children partook in the libations and tobacco consumption, while the younger children were happy just to play hopscotch or other childhood games. (Above, courtesy of Jim Mahan; below, courtesy of the Louis Belotti family.)

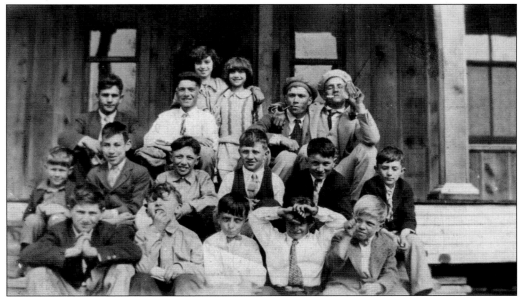

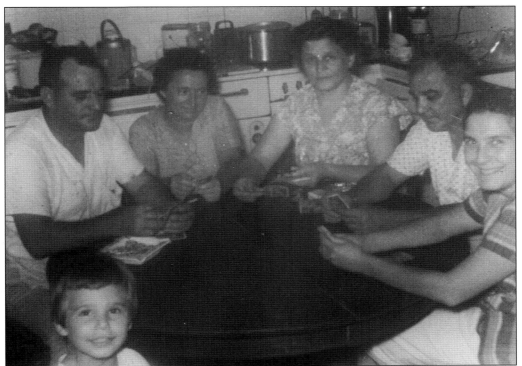

In the evenings, couples gathered to play card games like briscola and tresette, two games the immigrants brought with them from Italy. These games passed to the younger generation, and they played them to occupy their time, much as their parents had. (Courtesy of Angela Petursson.)

Young boys had a much different idea of fun compared to their parents and their female counterparts: horseplay. These boys pose with a variety of weapons like pistols, knives, and farm tools, some of which were pointed at the camera and others at the youngster crouching in the middle of the group. (Courtesy of the Louis Belotti family.)

Reese Creek flows for nearly three miles atop the mountain on which Little Italy sits. The creek carves its way through the mountain, creating a valley with impressive bluffs and steep, rock-covered hillsides. Like the surrounding hills, the creek is laden with sandstone. A natural rock formation that spans the width of the creek and resembles a horse's back intrigued the children of Little Italy because it created a natural pool in which they could swim and cool off from a hard day's work. Naturally, they called the formation "Horse's Back." The pool created by the rounded slab of sandstone is approximately 25 feet in circumference and can reach depths of 8 feet. (Courtesy of Loretta Crosariol.).

In addition to the overabundance of rocks at Horse's Back, poisonous water moccasins were always present during an afternoon swim, such as the one seen in the 1940s image. Olga Dal Santo recalled the following in a 2001 interview: "That rock . . . the snakes would be on top of it sunning, and we'd chase them in and they'd go out the other way, and we'd go swimming." (Courtesy of the Louis Belotti family.)

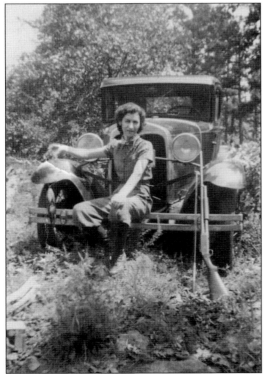

Fishing was also popular at Reese Creek. Though the fish were usually small, this did not stop many people for spending afternoons on the rocky banks trying to catch their dinners. Charles and Malia Belotti enjoy an outdoor excursion in these images from the early 1930s, which show the couple posing individually with their catches. (Both, courtesy of Martha Starks.)

America's pastime was a favorite among the young men of Little Italy. Baseball offered the Italians an easy opportunity for cultural assimilation with their American neighbors. On Saturday or Sunday afternoons, a rural circuit of teams competed against each other for local bragging rights. Angelo Belotti is seen here in his uniform before the start of a game in the mid-1930s. (Courtesy of Rico Belotti.)

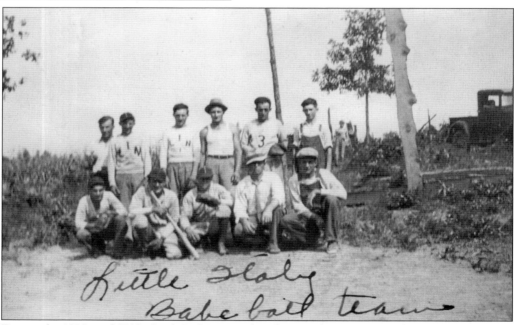

During the 1920s and 1930s, Little Italy's team played regional opponents such as Bigelow, Roland, and Houston at a baseball diamond near the Vaccari and Ghidotti farms. The games often headlined local picnics and bazaars and drew large crowds of community members who had few forms of entertainment available to them. (Courtesy of Jim Mahan.)

Hunting small game supplemented the diet of many of the families in Little Italy. This was usually the task of the boys of the family who hunted deer, rabbits, squirrels, and pheasants. While this was considered a chore because it was providing the family with food, the boys also found hunting to be quite enjoyable and therapeutic. (Courtesy of Olga Dal Santo.)

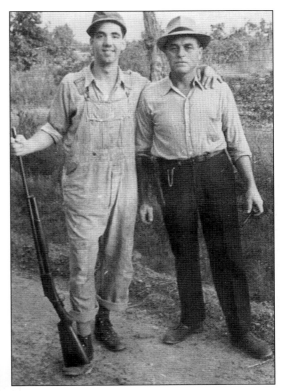

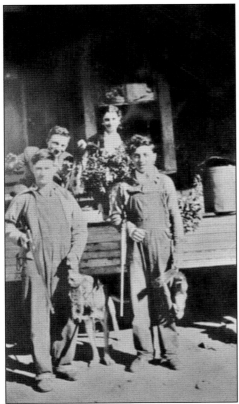

Raymond Vaccari, Richard Crosariol, and Johnny Segalla returned from a successful hunt with three squirrels between them. In addition to squirrels, this group was also known to hunt opossums, which they would share with older residents who no longer had young children to hunt for them. Unlike the other game, the opossum was an acquired taste and usually was served in soup. (Courtesy of Loretta Crosariol.)

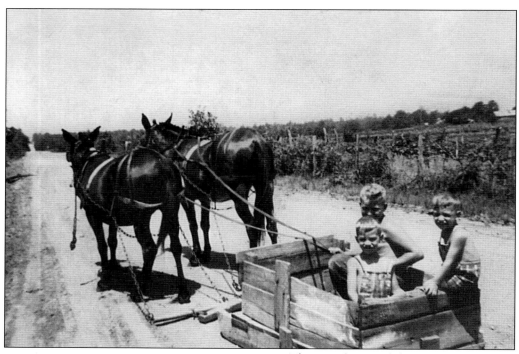

The use of automobiles to travel within the community was rare. Most people walked to visit neighbors or to buy supplies from the local businesses, and when necessary, mule-drawn wooden sleighs or wagons were often used to carry their purchases or transport large loads of produce to the railroad depot at Ledwidge. Sometimes, these sleighs also served as excellent entertainment for children on a beautiful spring or summer day. (Courtesy of Loretta Crosariol.)

Like the other inhabitants, Gelindo Solda used mules and horses to work his farm, and his truck for the long trip to Little Rock, but as a bachelor, he could purchase luxury items that those who had families could not afford. One such item was this motorcycle complete with sidecar, which he used to travel through the neighborhood and strike up conversation about this rarely seen mode of transportation. (Courtesy of the Louis Belotti family.)

Four

GOD, FAITH, AND COMMUNITY

As in the villages of their homeland, the settlers of Little Italy constructed their house of worship in the center of the community. Until the early 1920s, the Catholics held Mass at Ledwidge schoolhouse until they could build a church of their own. After petitioning Bishop John B. Morris of the Diocese of Little Rock, Little Italy's inhabitants erected a church with the help of the Catholic Extension Society. Thus, St. Francis of Assisi parish was founded in 1922 as a symbol of their deep Roman Catholic faith. They saw this as an offering to God for what they believed were bountiful blessings and recognized that the church was a monument to their community and testament to their success.

In addition to its ecclesiastical role, the church was the community's chief public building. Meetings were held there, community events took place on its grounds, and it served as the community's warning system. When an emergency occurred, such as a fire or a severe storm, the bells of the church tolled to warn the residents of the impending situation. When the bells were heard outside of a Sunday morning, it was clear to all of those hearing them that something was wrong.

As a manifestation of their faith, men maintained the church grounds and structure, while women sewed linens and decorated the church. Priests and seminarians instructed young and old alike in the catechism of the Church and provided the faithful with sacraments. At home, families displayed an intense devotion to God and the Virgin Mary; every home was filled with crucifixes, icons, and religious items that affirmed their connection to the church. Yards were adorned with ornate grottoes in honor the Blessed Mother, and in the spring, she was crowned with rose blossoms as the Queen of Heaven during the May Crowning ceremony at Mass. The Catholic faith played a central role in the relationships and traditions of Little Italy. The church bound the community together as it stood at the literal and figurative center of the village, just as it had in Italy.

St. Francis of Assisi Catholic Church stands as a cultural and religious symbol in the heart of Little Italy on land donated by the Perin family. The church building was originally erected in 1914 as St. John the Evangelist Church in Ola, Arkansas, when the town was a hotbed for loggers. Once Ola's timber industry slowed, there was an exodus of Catholics from the region, and the tiny church was shuttered. In 1922, Bishop John Morris granted a request by the Little Italians to establish a parish in the settlement; they purchased St. John's church and moved it to their settlement board by board. The building served the area until 1969, when it was replaced by a modern structure. (Left, courtesy of the Louis Belotti family; below, courtesy of Gina Drawbaugh.)

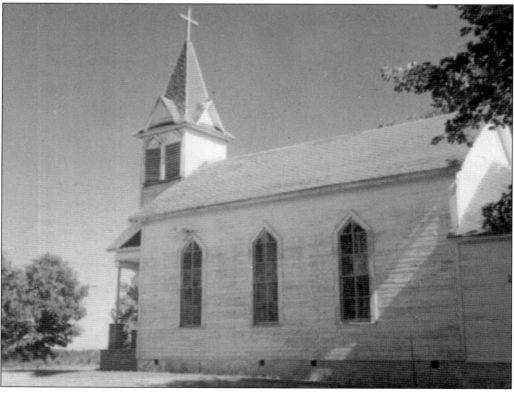

The main altar of St. Francis Church is seen in these photographs taken in the 1940s (below) and 1960s (right), respectively. Note the bronze plaque leaning against the center of the altar in the 1940s photograph. The plaque commemorates the donation in honor of Francis Knue made to the Catholic Extension Society of America, which enabled the church to be constructed. The charitable organization was established to spread the Catholic faith to frontier America by building churches among rural settlements. Knue was an Indiana farmer who died in 1916 at the age of 65. Two of his nine children became Roman Catholic priests. Nearly a century after Knue's death, the plaque is still displayed prominently in the vestibule of the church. (Right, courtesy of Loretta Crosariol; below, courtesy of Lenora Newman.)

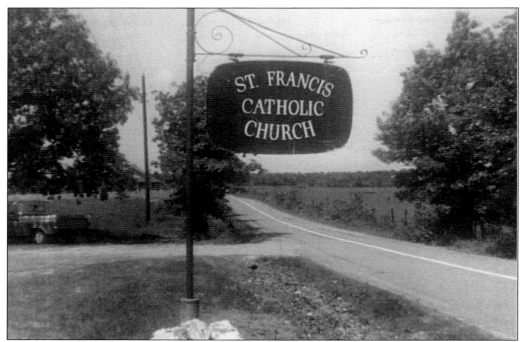

Shortly before her death Maria Busato Zulpo penned a brief memoir in Italian in which she shares the heartbreaking experiences she faced as a founding mother of Little Italy. To close her narrative, she begged future generations to heed the following request: "Non cambiate de posto alla chiesa che noi vecchi la biamo messa in mezzo al paese combiate i dire tari mo no la chiesa." Loosely translated, this means, "Don't move the place of the church. We old people put it in the middle of the community purposely and we are proud it is there." (Courtesy of Loretta Crosariol.)

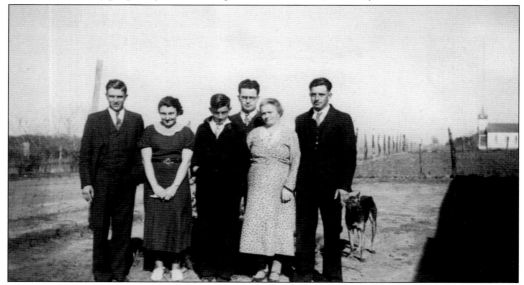

The church could be seen from across the entire colony, and it was a prominent backdrop for daily activities. In addition to the visual reminder, its bells were used to call worshippers to Mass and to warn them of emergencies. (Courtesy of the Louis Belotti family.)

Individuals throughout the community visited the church daily to say prayers, light candles, and maintain the building. Churchgoers like Brunetta Crosariol and Olga Dal Santo (pictured kneeling in the early 1940s) commonly prayed the Rosary or offered prayers for personal intentions. Both women and men took great pride in their village church. Ladies arranged flowers on the main and side altars weekly. Men performed maintenance on the structure by repairing the roof or removing wasp nests from the church's interior. Once, after a strong storm ripped through the area in the late 1920s, the men rebuilt part of the structure and added living quarters for their visiting pastor. (Right, courtesy of Lenora Newman; below, courtesy of Olga Dal Santo.)

Fr. Albert Fletcher was ordained a priest in 1920 and immediately appointed to the faculty of St. John's Seminary. From 1920 to 1923, in addition to his faculty position, Fletcher was pastor of St. Francis Church. To access his distant mission, Father Fletcher took a train on Saturdays from Little Rock to Ledwidge, a few miles from Little Italy. The priest spent the night at a parishioner's home, and after celebrating Sunday morning Mass, he lunched with his hosts and caught a train back to the city. Father Fletcher was the parish's first pastor, and this proved to be his only assignment as a priest. Just 20 years after being ordained, Fletcher was named the fourth Bishop of Little Rock, a position he held for 25 years. Though he became the spiritual leader of all of the Catholics in the state of Arkansas, Fletcher, until his death in 1979, remained close to the Italians who so graciously welcomed him as a young priest. (Courtesy of St. Francis Church.)

The initial rite of Roman Catholicism is baptism, in which original sin is washed away from the child, and he or she is welcomed into Christianity. The child's godparents vow to help raise him or her in the faith and often agree to care for the child should a tragedy befall his parents. In Italian communities, the concept of *santolo* (godfather) and *santola* (godmother) is so strong that those in the positions are viewed as blood relatives to the child. (Courtesy of Marie Rankin.)

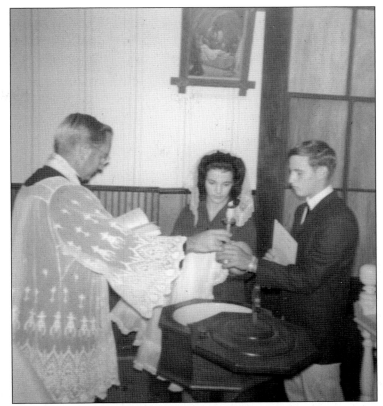

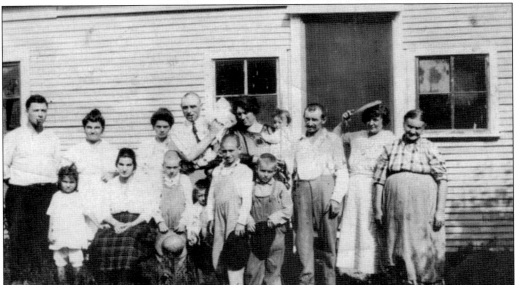

Gelindo Solda (second row, fourth from left) and Verina Cia (second row, third from left) served as godparents at Domonic Zulpo's baptism in 1922. Solda served as so many young people's godfather in the community that people simply referred to him as "Godfather" long before the film of the same name. (Courtesy of Lenora Newman.)

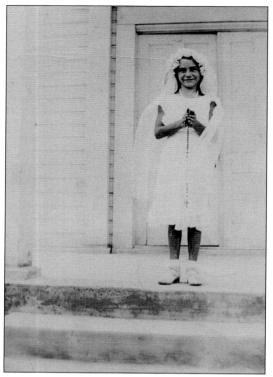

First Holy Communion is the second sacrament received in the Catholic Church. The children in Little Italy received instruction in catechism from seminarians attending St. John's Seminary in Little Rock. Boys and girls around seven years old are eligible to receive the sacrament after they have shown that they understand the concept of transubstantiation and make their first confessions. The first communicants are dressed entirely in white; the girls, who look like young brides, are usually dressed far more ornately than the boys. At the ceremony, the children receive a rosary, prayer books, and other religious items to remind them of their faith. Olga Vaccari (left), daughter of Ambrogio and Angela Vaccari, made her communion in the early 1930s, and two decades later, Johnny Segalla (below), son of Johnny and Louisa Segalla, did the same. (Left, courtesy of Olga Dal Santo; below, courtesy of Eda Segalla.)

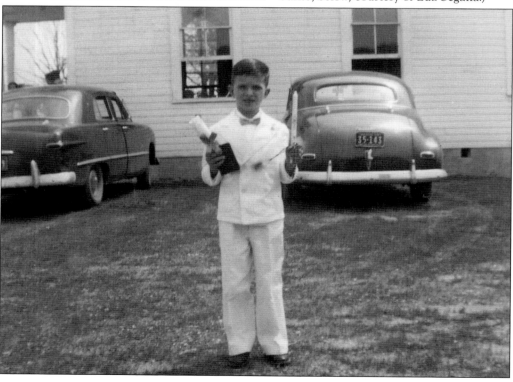

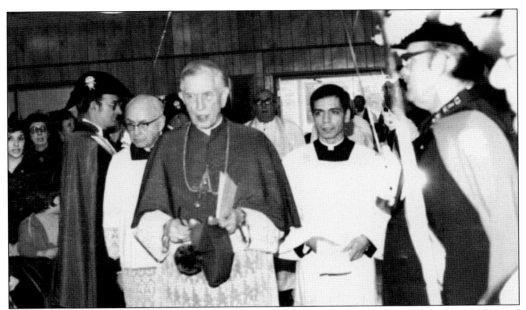

The sacrament of confirmation is bestowed on youths by the diocesan bishop who makes a pastoral visit to the parish to confirm the youngster's passage into Catholic adulthood. Confirmations at St. Francis during the reign of Bishop Albert Fletcher were like homecomings because of his history as the parish's first pastor. Fletcher is seen (at center) flanked by a Knights of Columbus honor guard and St. Francis pastors past and present. (Courtesy of St. Francis Church.)

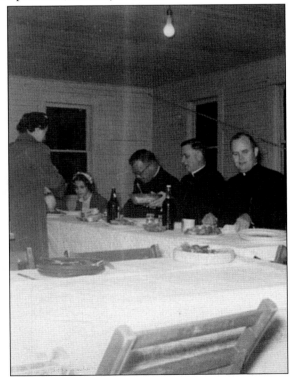

To honor the bishop and those receiving Confirmation, a long-standing tradition in Little Italy was to host a parish-wide dinner immediately following the ceremony. At the head table are, from left to right, Marie Chiaro, who was confirmed earlier in the day; parish pastor Fr. William Wellman; Bishop Fletcher; and his secretary, Msgr. John Bann. (Courtesy of Loretta Crosariol.)

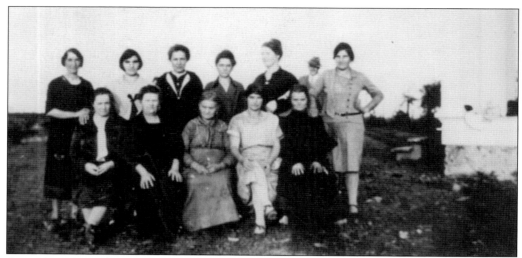

Around 1925, members of the St. Francis Altar Society pose on the front lawn of the parish church. The altar society is a Catholic women's organization that oversees the interior maintenance of the church, including caring for altar linens, clerical vestments, floral arrangements, and candles. Additionally, the organization provides charity for grieving families and others who need the organization's help. Pictured are, from left to right, (standing) Filomena Crosariol, Lena Zulpo, Lucia Segalla, Verina Cia, Maria Busato, and Maria Balsam; (sitting) Antonia Ghidotti, Annunziata Chiaro, Antionia Zulpo, Carlotta Carraro, and Maria Balsam. (Courtesy of Lenora Newman.)

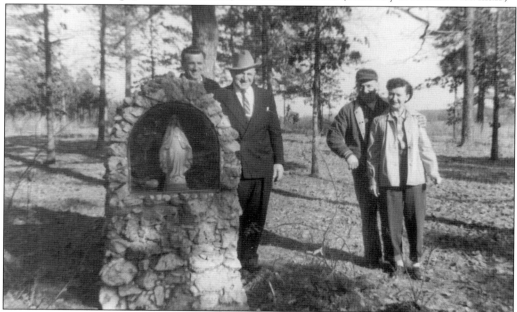

As a manifestation of their deep Catholic faith, numerous homes displayed grottoes dedicated to Mary, the Blessed Mother, and constructed from local quartz. These grottoes were tremendous sources of pride for their owners, and many women debated whose grotto was most ornate. The most impressive example of these monuments is a double grotto found at St. Francis Cemetery, which includes statues of Jesus, Mary, and St. Francis of Assisi, Italy's patron saint. (Courtesy of the Louis Belotti family.)

Religious holidays such as Easter were important cultural events in Little Italy. These images from the 1940s provide glimpses into how families celebrated such events within the community. Children and grandchildren gathered at the older generation's homes and dozens of relatives shared the day with each other. Large outdoor picnics were common among large families because, as the family grew, it was difficult to seat all of the members inside at a single table. This was the case for the Vaccari family, whose outdoor meal is shown at right. Below, Maria Belotti's grandchildren pose with full baskets behind her house after participating in a quintessential Easter egg hunt. (Both, courtesy of the Louis Belotti family.)

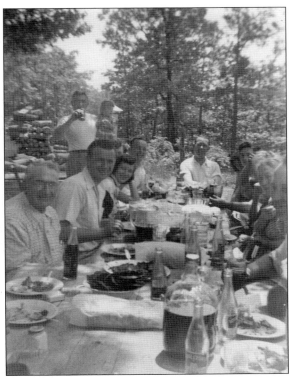

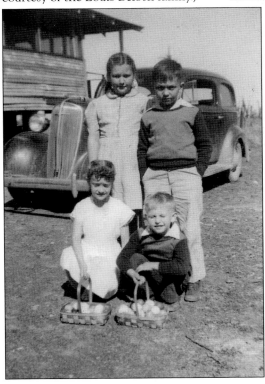

Beginning in the late 1940s, many of the area's original settlers passed away. By the 1970s, all of the area's founders were deceased. Legend has it that when Maria Belotti was younger she visited a fortune teller who predicted Belotti would die on her 75th birthday. Ironically, she died June 29, 1952—her 75th birthday. Like most religious events, funerals served as another example of the cultural assimilation that occurred in the community. As Belotti's body was laid out in her home for the wake, photographs were taken of the deceased in her coffin, and a steady of flow of visitors stayed with the body throughout the night. On the morning of her funeral, the body was transferred to the church and a Requiem Mass was celebrated for the happy repose of her soul. (Both, courtesy of Jim Mahan.)

St. Francis Cemetery is located approximately one mile from the settlement's church. At funerals that occurred early in the community's existence, mourners would walk with the coffin to the cemetery; by the 1940s, a long processional of automobiles would accompany the body of the deceased to its final resting place in the rocky mountaintop cemetery. (Courtesy of Jim Mahan.)

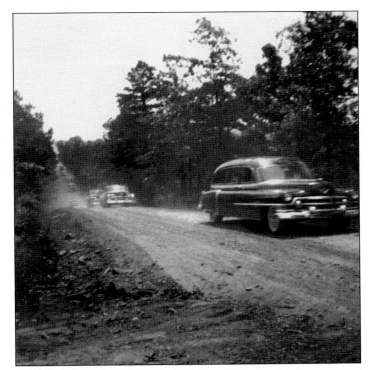

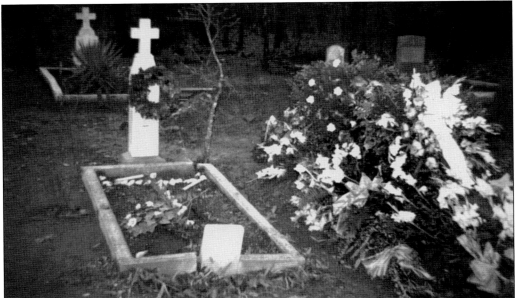

After an individual passed away, men assembled at the cemetery to dig the grave. The task was difficult given the rocky soil, and boulders were often blasted using dynamite to ease the process. Jugs of wine and moonshine were passed around to quench the thirst of the gravediggers and to help them forget about the task at hand. At times, locals also constructed the tombstones using terrazzo marble, but over time, these monuments crumbled because terrazzo is not an ideal material to use. (Courtesy of the Louis Belotti family.)

Serving as an altar boy was a common practice for Little Italy's young men. Boys began serving Mass alongside the priest at around eight years old. In the era before the Second Vatican Council in the 1960s, they were required to learn a great deal of Latin so that they could correctly respond to the priest's prayers during Mass. (Courtesy of the John Chiaro family.)

In addition to serving at Sunday Mass, altar servers assisted the priest on special religious occasions such as weddings and funerals. Here, two young boys assist Fr. Joseph Wenger at the funeral of Annunziata Chiaro in the 1940s. Wenger served as pastor of St. Francis parish from 1947 to 1950. (Courtesy of the John Chiaro family.)

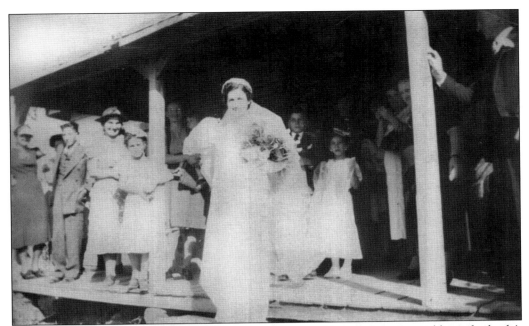

In a tradition that harkened back to the old country, on the morning of a wedding, the bride's family hosted a breakfast for the groom's family. After breakfast, the entire community gathered at the bride's home and walked to the church alongside the two families as a sign of solidarity. Malia Carraro's wedding in 1938 followed this tradition, as is seen by the large crowd gathered on her parent's front porch. (Courtesy of Lenora Newman.)

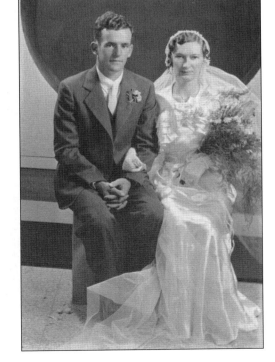

Louis Belotti and Irma Vaccari were married in October 1934. After walking to the church from the Vaccari home, the community celebrated at Maria Belotti's house for food, drink, and hours of singing. The young couple honeymooned in the home and did not get any sleep the first night, as guest upon drunken guest barged into their room to laugh, sing, and play jokes on the newlyweds. (Courtesy of the Louis Belotti family.)

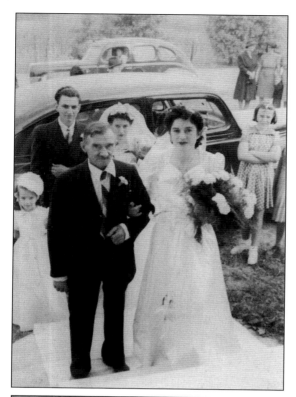

Ambrogio Vaccari escorts his daughter Olga into the church for her impending nuptials with Giovanni Dal Santo, a resident of Chicago. Five years her elder, Dal Santo met his 17-year-old bride by chance en route to a terrazzo job in Arizona. After completing his work, he returned to Little Italy for two weeks to visit before returning to Chicago. Dal Santo recalled that as the couple began talking marriage, Vaccari's mother wrote him and said, "My daughter is not going nowhere. You can come get her if you want her." After that, Dal Santo quit his job in Chicago, moved to Arkansas, and married his sweetheart. As of 2015, the couple is in their 73rd year of marriage. (Both, courtesy of Olga Dal Santo.)

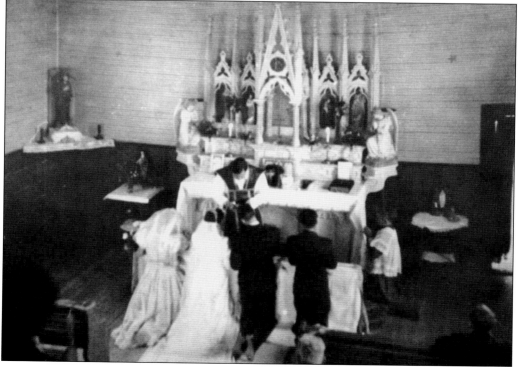

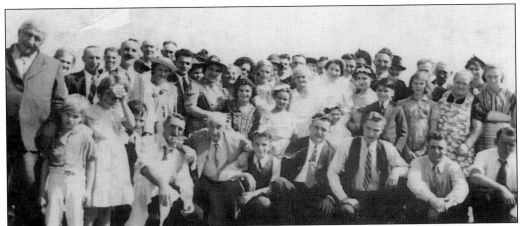

Traditional wedding receptions were typically hosted by the groom's parents and often lasted well into the night. In a 1990 interview with author Dr. James Woods, Louis Belotti recalled his wedding reception at which two distinct ethnicities blended together in song: "The German people from Dixie came down . . . and then they came over there to the house, and we had a big dinner. We had plenty of wine then, and bootleg whiskey, and the German people were sitting at this end of the table, and they'd sing a German song. And at the other end of the table, the Italian people, they'd sing an Italian song. I didn't think they'd ever leave that night, you know." (Courtesy of Lenora Newman.)

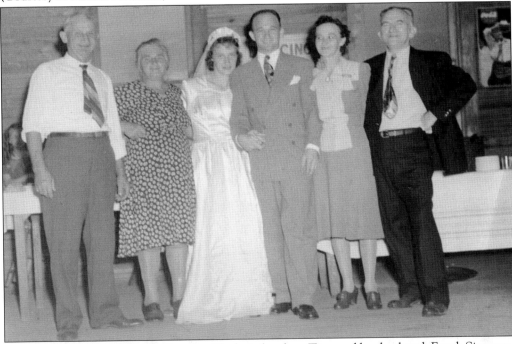

Bertolo and Maria Balsam (left) pose with their daughter Tina and her husband, Frank Siegman, at the couple's wedding reception in the 1940s. Frank's parents are on the right. While dancing to music provided by local accordion players, partygoers partook in vast amounts of traditional food and alcohol; this particular event was hosted at St. Francis parish hall. (Courtesy of Katherine Siegman.)

In the Catholic faith, May is dedicated to Mary, the mother of Jesus. On the first Sunday in May, a tradition called May Crowning occurs. During this celebration, the statue of Mary, commonly referred to as the Blessed Mother, is adorned with a crown of roses signifying her position as the Queen of Heaven. The youth of the parish have the honor of crowning the Blessed Mother in a processional complete with rose petals and singing of special Marian hymns. Here, the St. Francis Catholic Youth Organization prepares for the 1960 May Crowning. (Courtesy of Eda Segalla.)

Roses from bushes in every yard in Little Italy were used to adorn the church for May Crowning. The aroma of the blossoms filled the church, and parishioners took pride in knowing that everyone's flowers were used to help celebrate this sacred tradition. In 1960, Eda Segalla (center) crowns the Blessed Mother as Pauline Ghidotti (right) and Loretta Crosariol (foreground) look on. (Courtesy of Eda Segalla.)

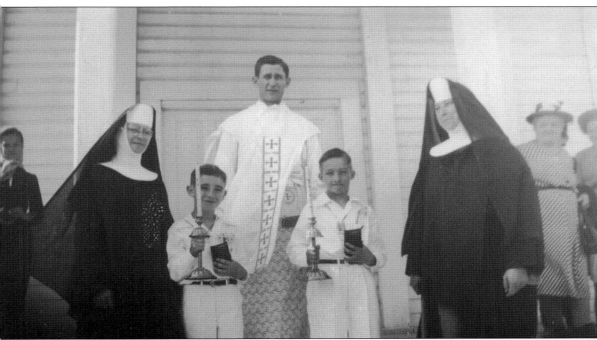

Beginning in the 1940s, Benedictine sisters stationed at the convent located at St. Boniface Church in New Dixie became fixtures in Little Italy's faith community. In the mid-1940s, education laws in Arkansas led to the consolidation of many small schools across the state, including the schoolhouse at Ledwidge. In response to the closing of their neighborhood school, the Italians sent their children to the parish school at St. Boniface instead of sending them to public schools in Bigelow. Founded in 1890 by sisters from St. Scholastica Monastery near Fort Smith, the school closed in 1968. After graduating from grammar school at New Dixie, most of the students from Little Italy went on to attend Catholic High School for Boys or Mount Saint Mary's Academy in Little Rock. (Courtesy of Pauline Ghidotti.)

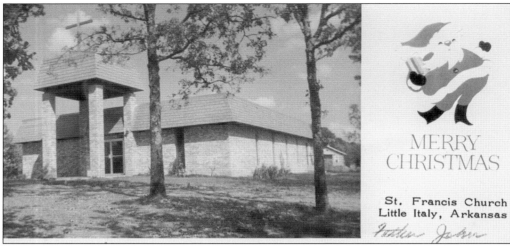

MERRY
CHRISTMAS

St. Francis Church
Little Italy, Arkansas

Rev. John Hlavacek served as pastor of St. Francis for a decade, from 1964 to 1974. In the years following Vatican II, Father Hlavacek championed a campaign to lead his parish into the modern era by constructing a new church to replace the aging structure originally built half a century earlier. Elements of the newly constructed church such as a terrazzo marble predella, on which the altar sits, hint at the craftsmanship of the local Italian artisans. The current church, finished in 1969, is pictured on the pastor's Christmas card of the same year. The boy pictured below is Richard Zulpo. (Above, courtesy of the Louis Belotti family; below, courtesy of Loretta Crosariol.)

Five

CELEBRATIONS AND FESTIVALS

Festivities celebrated for the amusement of the Little Italians were raucous, joyous events. Even on the most mundane weekend, locals gathered at the local dance halls to talk, drink, and dance into the night. Special religious occasions like births and baptisms were perfect excuses for a party. As soon as the religious rites were finished, without hesitation, secular celebrations immediately followed the solemn service. Impromptu music, dancing, and drinking were commonplace throughout the community, and everyone in town was always invited. Weddings were especially joyous events, which were not contained to a single reception but included numerous gatherings over several days. At each, the traditional foods and drinks of Italy were served to friends and visitors from around the region who joined in the fun. For the hardworking immigrants, these events offered much-needed breaks from their daily, hardscrabble lives.

By far the most anticipated event was the annual grape festival beginning in the late 1920s. Originally a two-day event, the festival attracted thousands of attendees who read stories about the colony's "sweet grape juice," and instantly knew that they would traverse the winding roads to the village to stay the weekend for a truly "cultural" experience. The event became an institution throughout the vicinity, as throngs of people listened to various local, state, and national politicians who seized the opportunity to speak to large crowds of happy festivalgoers. Spaghetti and roasted chickens were served, as well as other Italian dishes for which the settlement was well known. Throughout the years, new forms of entertainment were added to the bazaar, including dancing, movies, games of chance, and baseball games.

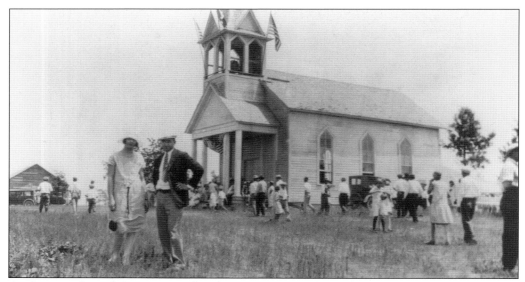

Anthony and Pearl Carraro stand in front of St. Francis Church, complete with Italian and American flags hanging from the belfry, as eager visitors await the beginning of the local grape festival. Beginning in 1927, the two-day festival was held each year to mark the grape harvest. During this respite, locals treated themselves to music, dancing, games, and copious amounts of food and drink. It was the last part that caught the attention of thousands of Arkansans from across the region who converged upon the small town at the end of the summer each year to enjoy the Little Italy Picnic, with its ethnic fare, liquor, and, of course, grape harvest, which ensured another batch of happiness the following year. The end of Prohibition in 1933 did not hamper the popularity of the event, as indicated by this 1936 advertisement that highlights the numerous types of entertainment and activities available for Depression-era festivalgoers. St. Francis Church continues to host this event, which marks its 88th year in 2015. (Above, courtesy of Lenora Newman; below, courtesy of the *Arkansas Catholic* Archives.)

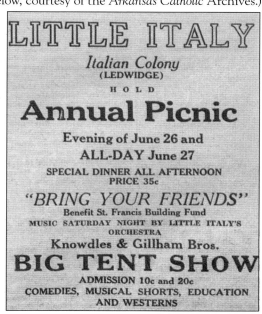

Arkansas senior senator Joseph T. Robinson headlined the annual grape harvest festival in 1927. According to the August 6, 1927, edition of the *Guardian*, when Robinson spoke to the large crowd gathered there, he "lauded the establishment of this splendid Italian colony and commended the members upon the great development of their landed holdings." Robinson's visit is indicative of Little Italy's prominence in Central Arkansas during this time. He recognized the settlement's unique position as an ethnic enclave, and as a provider of the area's alcohol. Robinson used this opportunity to promote his anti-Prohibition position among a largely receptive crowd who visited Little Italy's festival to purchase wine and moonshine. By 1928, Robinson gained further national spotlight when he was chosen as the Democratic nominee for vice president alongside Catholic running mate Gov. Al Smith of New York. (Courtesy of the Library of Congress.)

Estimates placed the Prohibition-era grape festival's attendance at more than 4,000 people in 1927. Four years later at the 1931 event, the *Arkansas Gazette* reported, "The public was invited and heartily welcomed . . . The first day was devoted solely to merry-making, dancing and hoopla. . . . The morning of the second day . . . then it is that they take time to eat . . . They eat and eat and eat and eat, and then when too full of spaghetti, chicken, and sweet grape juice ever to think of food again, they go back to the old Roman custom of eating once more." While the paper mentions "sweet grape juice," this was not the case, rather attendees partook in wine and other adult beverages. In this photograph, drinks are being sold for 5¢ "a cup," while spaghetti costs 25¢ "a dish." (Courtesy of Pauline Ghidotti.)

Each woman made pasta and provided more than 20 fryer hens for the meal that accompanied the grape festival. Pasta required few ingredients, but was extremely laborious and time-consuming for the ladies to produce. The pasta dough was rolled out paper thin and cut into quarter-inch strips using a knife. The pasta was then dried on racks and stored for later use. By the 1950s, pasta machines, like the one used by Clara Dal Santo Bortoli in these images, made the production of pasta much less labor-intensive, but the task remained time-consuming. (Both, courtesy of Margaret Forrester.)

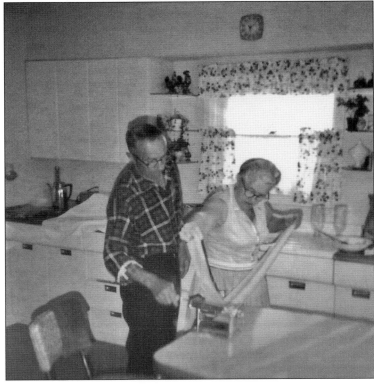

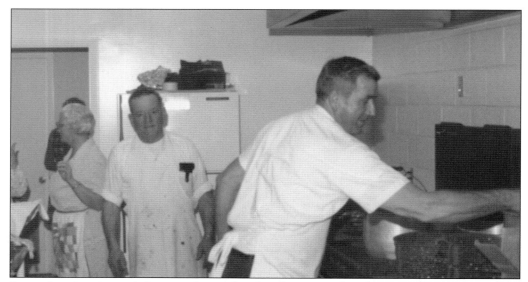

Even after the vineyards became diseased and no longer produced grapes, the tradition of the festival continued. Hundreds of pounds of spaghetti and nearly 100 gallons of sauce were produced annually for the festival hosted by St. Francis parish. Jovanna Cortese, Louis Belotti (center), and John Dal Santo (right) are pictured here in the 1970s working in the kitchen, preparing food for the day's visitors. The bazaar was a key political event during election years, and numerous politicians visited seeking to attract would-be voters. In 1980, future president Bill Clinton, then Arkansas's governor, served spaghetti to shocked patrons. (Courtesy of St. Francis Church.)

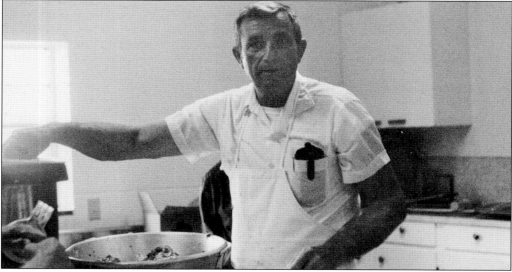

Italian sausage replaced roasted chicken as the side dish offered at Little Italy's dinners in the 1950s. Each year, the community's men made 800 pounds of sausage—until 1980, when they began allowing local butchers to produce the links using the original recipe. Here, John Dal Santo oversees the grinding and stuffing of the final batch of homemade sausage before production was turned over to retail outlets. Patrons purchased raw sausage by the pound to take home in an attempt to emulate its distinct taste when cooked in the special wine blend at the bazaar. (Courtesy of Olga Dal Santo.)

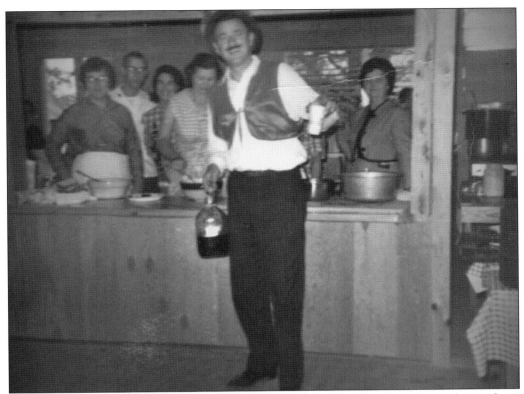

Visitors to Little Italy were treated to good food and a welcoming atmosphere during the spaghetti dinner and festival. Patrons received free glasses of wine while accordion music bellowed romantic tunes from the Old World for those waiting in line for their food. Numerous games of chance set up in booths across the churchyard provided visitors with entertainment after they finished their meals. (Above, courtesy of Olga Dal Santo; below, courtesy of the Louis Belotti family.)

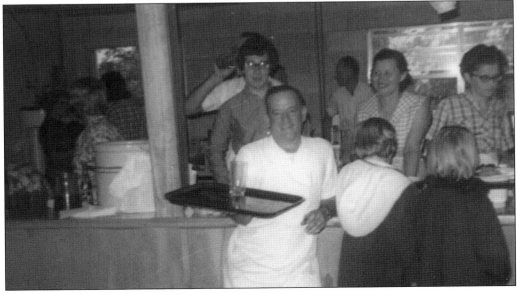

Despite the hard work it took to organize the event, the spaghetti dinner offered residents of the community a chance to welcome back old friends and show hospitality to new festivalgoers who were sure to return in the future. The fun-loving environment allowed everyone to have a good time. Over the years, the proceeds from the dinner went to the construction of a new parish hall, dedicated in 1977. (Above, courtesy of Loretta Crosariol; below, courtesy of St. Francis Church.)

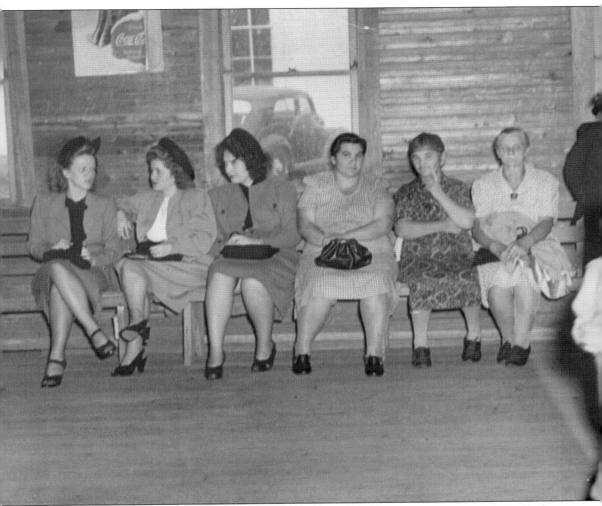

St. Francis Parish Hall was the setting for many dances, wedding receptions, and parties before it was replaced with a newer building in the late 1970s. Built-in benches situated on the walls surrounded the dance floor and provided a place for people to visit while they watched couples dance through the night. During the 1950s, movies rented from theaters in Little Rock were shown here, and the community gathered to see recent films and eat popcorn as though they lived in a much larger town. (Courtesy of Katherine Siegman.)

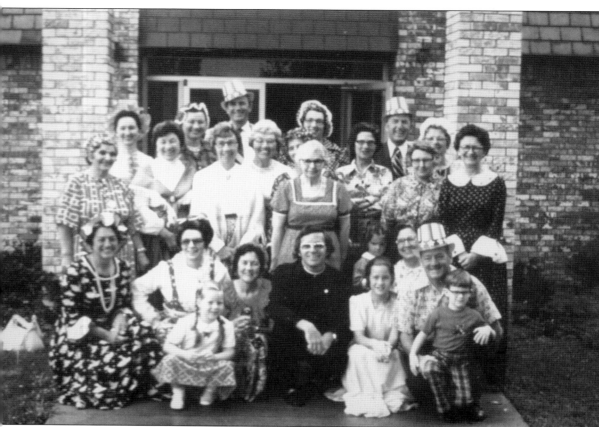

Deeply proud of their American struggle, Little Italy's residents joined their countrymen in celebration of the nation's bicentennial. Inhabitants marked the occasion with a variety of events focusing on civic pride. Some individuals partnered with a local historical association to compile a book about the communities in Perry County, while others dressed patriotically and took part in Independence Day activities. In recognition of its role in highlighting America's birthday, Little Italy was named a "Bicentennial Community" and received a certificate from Pres. Gerald Ford praising the community's citizens for their dedication. (Courtesy of St. Francis Church.)

Six

LITTLE ITALY'S WIDER INFLUENCE

Though geographically isolated by rugged dirt roads and mountainous terrain, the settlement's impact was ever-present in the wider community. Local vintners enjoyed the respect of politicians at every level of government because of the reliable liquor they exported, and visitors from surrounding counties came to the secluded locale to enjoy the wine and moonshine without fear of arrest. After the repeal of Prohibition in 1933, the production of wine intensified, and consequently, four wineries were reestablished in the same manner in which they operated two decades earlier. The colony's annual bazaar attracted throngs of festivalgoers and served as a cultural oddity in a region with few Italians or Catholics, thus adding to the exotic mystique of the town.

Bushels of apples, pears, peaches, and grapes were shipped out of area farms, bound for markets near and far, and the only horseradish producer in the region was headquartered here. Moreover, the enterprising spirit of some of the town's residents expanded to nearby Little Rock, where the Cias owned a restaurant at Markham and Spring Streets, Domenico Zulpo operated a hot tamale stand on Main Street, and the Belotti brothers opened a garage in the now famous Argenta district of North Little Rock.

Skilled craftsmen used their knowledge of stonemasonry to construct notable landmarks around Arkansas, and the area's terrazzo setters worked on public buildings throughout the country. During the Depression, men worked in many New Deal programs such as the Civil Conservation Corps (CCC) and the Works Progress Administration (WPA) to construct the state's blossoming infrastructure. Little Italy's young men served in every major American conflict from World War I to Vietnam. To continue this theme of service, regional fire and police departments drew many of these soldiers to fill their ranks, including Capt. Johnnie Cia, who died in service to the city of Little Rock.

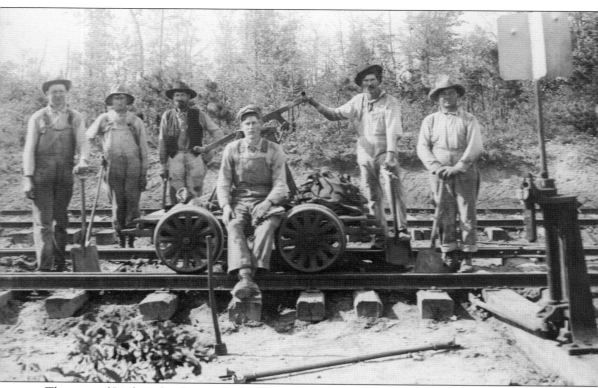

The men of Little Italy often worked in Little Rock or other neighboring towns to supplement their incomes after they finished the grape harvest each year. Many men worked for local lumber companies or helped maintain regional railroad tracks. As the Great Depression intensified, it proved increasingly difficult for the men to find extra jobs. Thus, they depended more on selling wine and cognac to liquor-deprived central Arkansans, and because of this, they became more culturally assimilated and accepted. (Courtesy of Jim Mahan.)

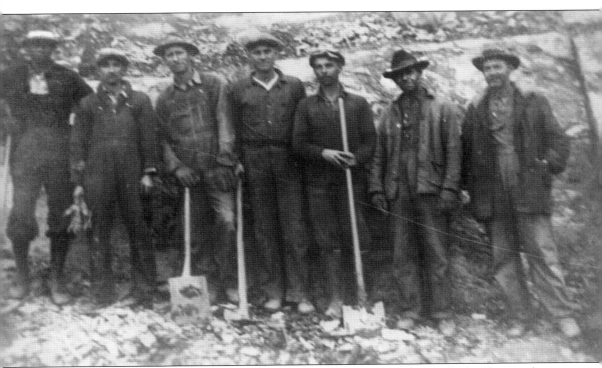

Many men labored in the bauxite mines of Saline County or dug ditches for local natural gas companies. Brunetta Crosariol mentioned in a 2001 interview that "there was no work here in the community, so many of them worked for the gas companies . . . digging ditches to put pipes in—some of the Ghidottis and Balsams, they did that quite a bit. That's when they started working away from home . . . they had to." Those who worked in these positions returned home only once or twice monthly. (Courtesy of Jim Mahan.)

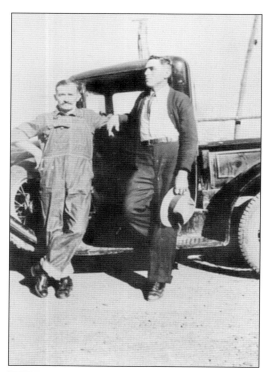

Due to the less than reliable roads to and from the settlement, few families owned automobiles before the 1940s. To ease the travel to nearby towns, many of the community's men carved a road along the edge of Kryer Mountain (the mountain on which Little Italy sits) using plows, mules, and dynamite. Before that time, flat tires and broken axles were commonplace on an all-day excursion to Little Rock for business. (Courtesy of Loretta Crosariol.)

In the early 1930s, travel to and from Little Italy was made easier after Arkansas Highway 10 was paved. The road, known as the Joe T. Robinson Highway, took travelers headed to the village to a junction called Crossroads—an area that is currently underneath Lake Maumelle—before climbing the mountain up to the settlement. (Courtesy of the Louis Belotti family.)

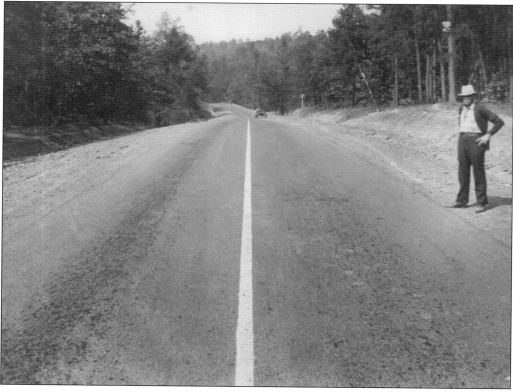

During the 1920s and 1930s, Carl Bailey served in the prosecuting attorney's office of Arkansas's Sixth Judicial District. In this capacity, Bailey became acquainted with the winemakers of Little Italy and used his influence in the courts of Pulaski and Perry Counties to help the residents of Little Italy avoid prosecution for violating Prohibition laws. By 1934, Bailey was elected as the Arkansas attorney general; within two years, he was a popular New Deal governor. As a politician, Bailey is most noted for orchestrating the 1936 arrest and extradition of famed mafia leader "Lucky" Luciano. When captured at Hot Springs, Luciano offered Bailey $50,000 not to extradite him to New York, where he faced numerous charges. In a case that gained national attention, Bailey returned the mobster to New York instead of collecting his bribe. Coincidentally, on the day of his most famous political triumph, Bailey stopped in Little Italy to dine at the home of Ambrogio and Angela Vaccari along with members of the state police who accompanied him to Hot Springs to make the arrest. (Courtesy of UALR Center for Arkansas History and Culture.)

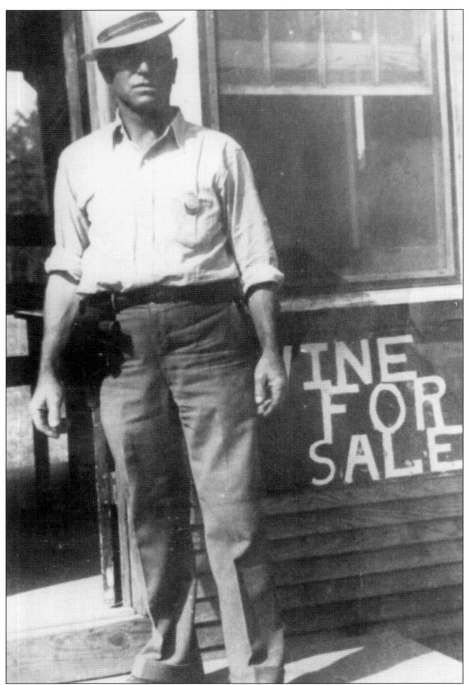

During the illustrious political career of Solda's close friend Carl Bailey in the 1930s and 1940s, protecting Little Italy's liquid capital interested local politicians so much that Solda was made a Pulaski County sheriff's deputy in order to protect it and to keep law and order at the sometimes raucous tavern he owned. Note the sheriff's badge above his left breast and his sidearm in its holster on his right hip. (Courtesy of Olga Dal Santo.)

A patron (right) poses with his purchases alongside Americo Segalla from the Segalla winery. The purchase included nearly a gallon of cognac and an equal amount of wine distributed in three bottles. According to Louis Carraro in 2002, "People would come up here from Little Rock and all over the country. They knew about Little Italy where you could buy wine, you know, illegally." (Courtesy of Eda Segalla.)

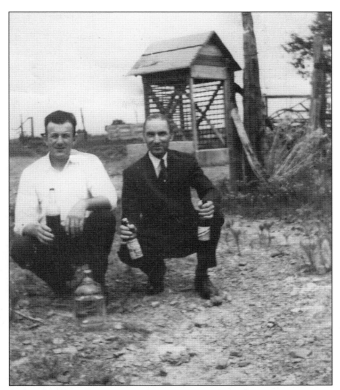

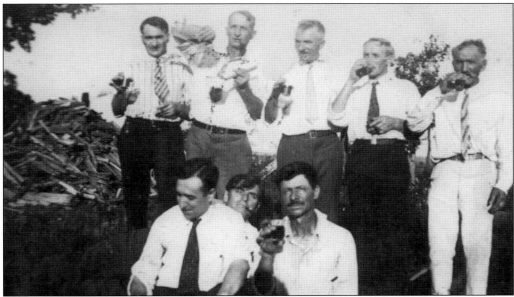

The liquor magnates of Little Italy, which included the owners of the area's four wineries, two beer joints, and dance hall, toast a successful grape harvest in July 1930. "*La festa dell'uva*," or grape festival, was a widely anticipated event in the community as it was one of the few times during the year when everyone celebrated and offered thanksgiving for a fruitful harvest. (Courtesy of the John Chiaro family.)

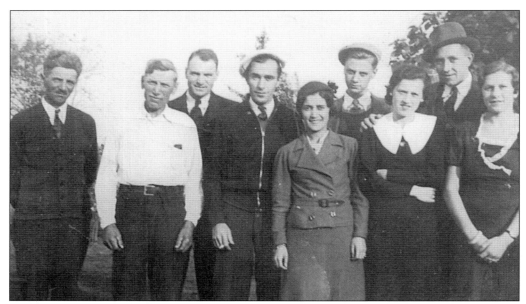

Well-dressed Sunday visitors, such as the group seen here, were common during Prohibition. The Italians depended on these large groups who might collectively purchase large quantities of wine or cognac. As Irma Vaccari Belotti recalled in a 2001 interview, "I know we didn't have any money at all, and it was around Christmas, and they said it's going to be a poor Christmas . . . they sold ten gallons of wine and got $20 from someone, one of them that came, but boy we were happy because we got $20 for Christmas." (Courtesy of Loretta Crosariol.)

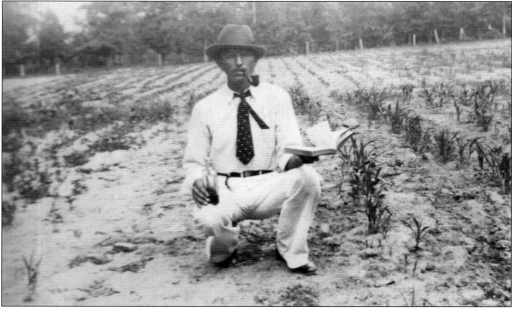

Those in philosophical opposition to Prohibition often tempted fate by having their pictures made in Little Italy with alcohol so that they could brag to their friends about their most recent purchase. This visitor poses with his Bible in one hand and a pint of wine in another while standing in his liquor supplier's corn and potato patches. (Courtesy of Jim Mahan.)

With smiling faces and donning aprons, Gelindo Solda (center) and his friends (from left to right) Carlotta Carraro, Lucia Segalla, and Angela Vaccari greet visitors arriving to purchase liquor at Solda and Vaccari's tavern. During Prohibition, wine and cognac were sold throughout the settlement. Wine sold for $1.50 per gallon; cognac cost $4.50 per gallon. The fear of overzealous Prohibition agents arriving unannounced weighed heavily on the minds of the residents. (Courtesy of the Louis Belotti family.)

A visitor to Little Italy's beer joint enjoys a shot of the local hard liquor of choice—cognac, distilled from the hulls of grapes. Ambrogio Vaccari and his 11-year-old son Raymond were arrested for selling cognac to an undercover agent at this tavern in the early 1930s. During their arraignment, the judge dismissed the case, and Vaccari was released to his wife, telling her, "Just don't say anything. Take up and go." After the experience, Vaccari vowed never to make liquor again. According to his children, Vaccari soon received a message from the Arkansas attorney general, the judge, and the Pulaski County coroner that said, "You make it. You just make it for us." (Courtesy of Katherine Siegman.)

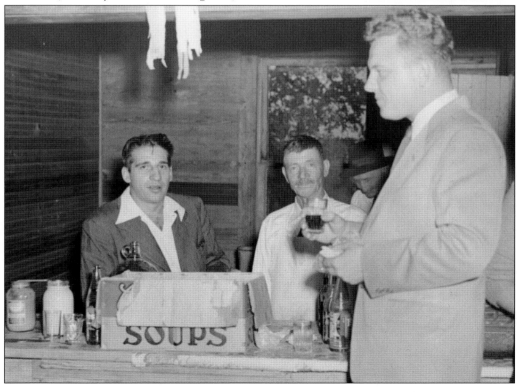

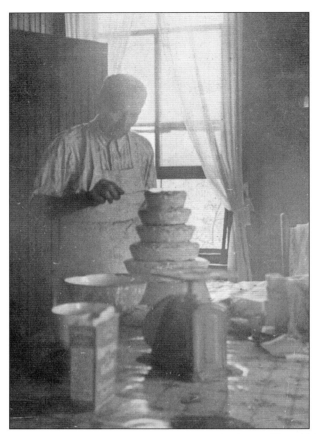

Despite the appearance of a singular, agricultural skill base, the inhabitants of Little Italy brought with them a myriad of life skills that they acquired in Italy and upon arrival in the urban centers of the United States. One example is Joseph Dal Santo, a master baker before moving to Arkansas, who is shown here preparing a wedding cake, which would serve as his gift to the young couple. (Courtesy of Olga Dal Santo.)

John Zulpo (center with hat) was an accomplished stonemason who oversaw construction of numerous projects throughout the state of Arkansas, most notably the elaborate stonework at Petit Jean State Park near Morrilton. The structures and nature trails at Petit Jean, Arkansas's first state park, were constructed by Arkansas World War I veterans who served in the Civil Conservation Corps (CCC), a program started by Franklin Roosevelt's New Deal in 1933. (Courtesy of Lenora Newman.)

Domenico Zulpo learned how to make hot tamales while working in the Arkansas Delta at Sunnyside Plantation among the numerous Mexican migrant workers. Because of the similarities of their languages, communication between the immigrants was easier than with other ethnic groups, which allowed for an exchange of ideas to occur. When Zulpo moved to central Arkansas, he introduced the region to tamales using a street vendor's cart, which he set up on Main Street in downtown Little Rock. Zulpo is shown here holding a plate of tamales alongside his glass-sided cart. Sadly, this severely damaged image is the only known photograph to exist showing Zulpo and his tamale stand. (Courtesy of Lenora Newman.)

Brothers Charles and Louis Belotti owned and operated the Belotti Brothers Garage in downtown North Little Rock beginning in the 1940s. Charles used the knowledge he gained as a mechanic during World War II to open the business with his older brother. (Courtesy of the *Arkansas Catholic* Archives.)

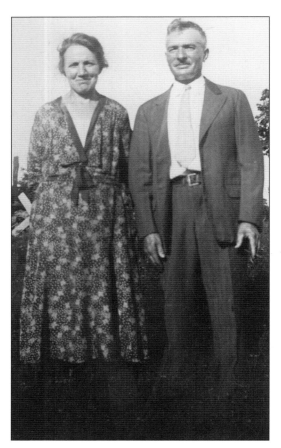

John Segalla introduced the Arkansas palate to horseradish with the establishment of his factory in Little Rock during the 1920s. The horseradish root has been used throughout history as an herbal medicine and, within the last five centuries, as a flavor enhancer in food. Used throughout Southern Europe, horseradish was very common among spicy food enthusiasts in the era before modern hot sauces. (Courtesy of Eda Segalla.)

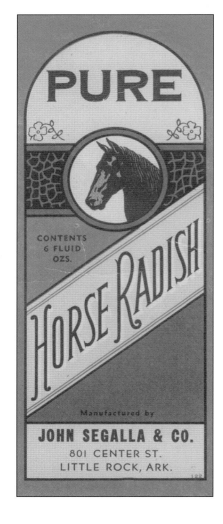

PURE

CONTENTS
6 FLUID
OZS.

HORSE RADISH

Manufactured by
JOHN SEGALLA & CO.
801 CENTER ST.
LITTLE ROCK, ARK.

The John Segalla Company used this label on six-ounce bottles of pure horseradish. The mashed root of the horseradish plant was combined with vinegar to preserve its color and potency and was used as a condiment on numerous varieties of beef, fish, and wild game. The product was sold throughout the region and was carried by most grocers. (Courtesy of Louis Segalla.)

Gabe Chiaro (right) was an accomplished accordion player. After studying at the Zordan Music House in Chicago during the 1920s, he became an instructor at the school for many years before returning to Arkansas to start his own school. In the 1940s, he established the Chiaro Accordion School in downtown Little Rock, where he instructed both beginners and advanced accordion players and carried a wide selection of accordions for purchase or rental. (Above, courtesy of Lenora Newman; right, courtesy of the *Arkansas Catholic* Archives.)

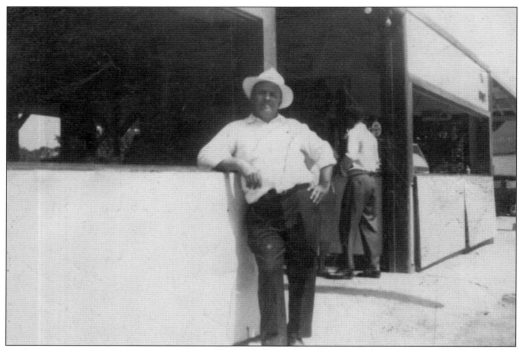

In the midst of the Depression, many of Little Italy's younger generation sought work throughout the country using skills gleaned from traditional Italian methods of construction. One such skill was setting terrazzo marble floors, a popular flooring treatment for high traffic, commercial locations. Angelo Zulpo traveled throughout the country installing terrazzo in many hospitals and governmental buildings. Zulpo is seen here in downtown Kansas City, Missouri, during one of his business trips. (Courtesy of Angelina Dunlap.)

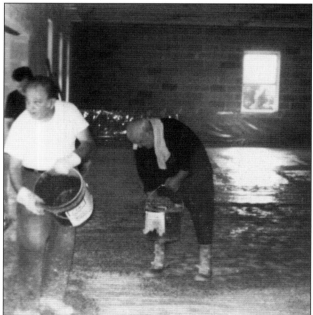

Installing terrazzo is a multistep process that requires many different materials, most importantly marble chips. While the mortar mixture is wet, workers toss marble chips of various colors into metal dividers used to create designs or serve as expansion joints, and color may be added to the different sections to enhance the design. Afterward, a weighted roller is used over the entire surface as more marble chips are added. After the floor dries, it is ground, polished, and sealed. (Courtesy of St. Francis Church.)

In 1917, just a few years after arriving in Arkansas with his family, Joseph Belotti lied about his age to join the Navy as the United States entered World War I. As the eldest child, Belotti helped his father on the farm, but there was often too little food to go around in the family of seven. It was this lack of food that compelled him to join the war effort, and he never returned to Arkansas before his death from the Spanish flu epidemic of 1919–1920. (Courtesy of the Louis Belotti family.)

In 1916, Italy abandoned its allegiance to Austria-Hungary and Germany and joined forces with the British and French. By the time the United States entered World War I, the two nations were allies, which made it easier for immigrants like 27-year-old Gelindo Solda (left) to serve in the US military without rising in opposition to their native land. John Zulpo (below), who was also born in Italy, was drafted and stationed in France beginning in 1917. (Left, courtesy of Loretta Crosariol; below, courtesy of Lenora Newman.)

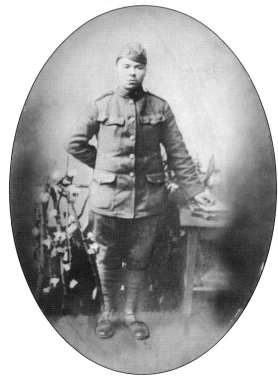

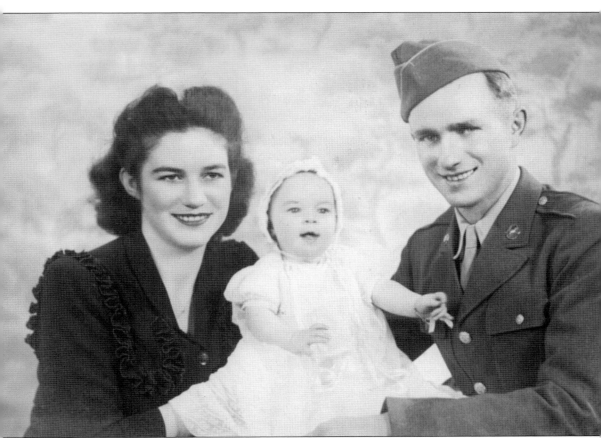

The late 1930s and early 1940s was a contentious time not only across the world but in Little Italy as well. The older generation feared its sons going to war if the United States became involved and also had a keen awareness of the events in Europe involving Italy. In a September 1939 *Arkansas Democrat* article, Domenico Zulpo asserts, "Italy remembers the World War when they were persuaded to help the Allies . . . but when the spoils were divided, they got nothing . . . I am for neither side . . . We have no more reason for taking sides than we did during the World War, and we had no reason at all then . . . and what good did it do?" When the United States entered the war in 1941, the community braced for the impact of losing its sons, brothers, and fathers. John Dal Santo, seen with his wife and daughter, received a Purple Heart for his service in the European theater. (Courtesy of Olga Dal Santo.)

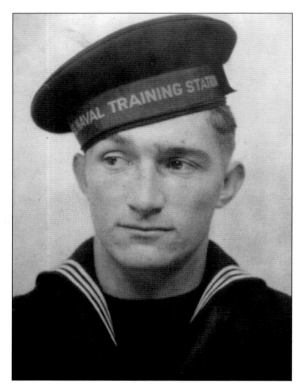

The conscription of soldiers during the war created a labor vacuum in Little Italy. Men from nearly every family in the community served in one branch of the armed forces or another, and their absence dealt a blow to the local economy. Raymond Vaccari (left) was the only male child in his family and was one of the few to join the Navy from the town. Vincent Zulpo (below), however, was one of several children from the same family to enter into the service. In both of these instances, the families struggled to continue the day-to-day operations of their farms because of the absence of the young men. Though many of the area's men fought in the war, there were no casualties among the Italian soldiers. Instead, most of the veterans died much later in life and are interred at St. Francis Cemetery. (Left, courtesy of Olga Dal Santo; below, courtesy of Lenora Newman.)

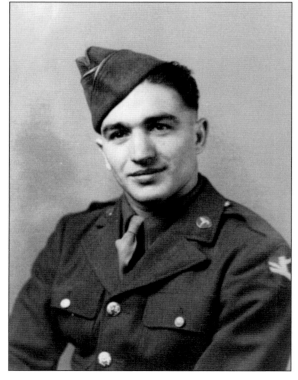

Several of Little Italy's younger generation went on to serve in the capital city's fire department or police force. One such individual was Raymond Vaccari (left), who served as a Little Rock police officer for over 20 years. (Courtesy of the Louis Belotti family.)

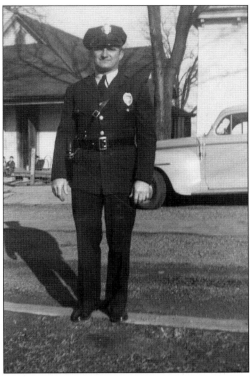

Throughout the second half of the 20th century, the Little Rock Fire Department included several Little Italy natives. One such example is Capt. Johnny Cia, pictured here. On the evening of January 23, 1961, the firefighter was fatally injured in an accident between his fire engine and an automobile while his company responded to a false alarm. He is memorialized at the Arkansas Fallen Firefighter's Memorial, part of the state capitol complex in Little Rock. (Courtesy of DJ Cia.)

DISCOVER THOUSANDS OF LOCAL HISTORY BOOKS FEATURING MILLIONS OF VINTAGE IMAGES

Arcadia Publishing, the leading local history publisher in the United States, is committed to making history accessible and meaningful through publishing books that celebrate and preserve the heritage of America's people and places.

Find more books like this at
www.arcadiapublishing.com

Search for your hometown history, your old stomping grounds, and even your favorite sports team.